A
BRIEF HISTORY OF
TREMONT

—∞—

Cleveland's Neighborhood
on a Hill

W. DENNIS KEATING

THE
History
PRESS

Published by The History Press
Charleston, SC
www.historypress.net

Cover image: Church photo by Matthew Ginn (www.MatthewGinn.com).

First published 2016

ISBN 978.1.54021.238.2

Library of Congress Control Number: 2015956831

Notice: The information in this book is true and complete to the best of our knowledge. It is offered without guarantee on the part of the author or The History Press. The author and The History Press disclaim all liability in connection with the use of this book.

This book is dedicated to the pioneering spirit of the residents of Cleveland's Tremont neighborhood over the course of almost two centuries—from the early New England settlers to the founders of Cleveland's first university, immigrants from abroad and migrants from Appalachia and Puerto Rico who made their way to Tremont and the mills of the industrial valley, the artists and restaurateurs who helped to launch the revival of Tremont from its worst times and those in the many community and religious organizations, institutions and businesses who have fought for the neighborhood's interests.

CONTENTS

CONTENTS

PREFACE

During my career at the Levin College of Urban Affairs at Cleveland State University, I have researched, written and taught about many Cleveland neighborhoods, Tremont among them. In 2006, I co-authored an article in the journal *Community Development* (vol. 37, no. 4) about the long-term impact of the Tremont West Development Corporation on the Tremont neighborhood. While I already knew a lot about the Tremont neighborhood before I began to write this book, I learned far more about its history and its current status while doing the research (including visits to several Tremont events) for this book. Without the help of numerous individuals and key resources, I could not have adequately told the fascinating story of this ever-changing Cleveland neighborhood.

ACKNOWLEDGEMENTS

This book would not have been possible without the help that I have received from many people as well as key resources. First, the cooperation of the staff of the Tremont West Development Corporation has been invaluable, as well as access to its archives, including its monthly newspaper, *Inside Tremont*. Second, the Cleveland State University History Department's Tremont Oral History project archives allowed me access to numerous past interviews of Tremont residents and leaders, many of which I have quoted. Third, Cleveland Historical, the *Encyclopedia of Cleveland History*, the Ukrainian Museum-Archives and Teaching Cleveland Digital's Tremont link from its NE Ohio Neighborhoods and Their History were essential resources, as were local newspapers (the *Plain Dealer*, the *Plain Press* and *The Tremonster*). Fourth, I also conducted numerous interviews myself with the assistance of Cleveland State University's History Department's Cleveland Regional Oral History Project in the Center for Public History and Digital Humanities. Erin Bell was most helpful. While I am not listing here by name all those whom I personally interviewed, without their insights and memories this book would not have been possible. Another source about Tremont is found on Facebook in the page for Memories of Tremont—Cleveland's Southside.

Bill Barrow, special collections librarian at Cleveland State University and the custodian of the Cleveland Memory Project, was very helpful in searching for Tremont articles and photos, as was Vern Morrison for retrieving historical Tremont photos. Several readers reviewed drafts of this

book, improving it considerably as well as catching my errors and omissions. Special thanks go to my wife, Kay Martin; David Goldberg; Chris Roy; Cory Riordan; Scott Rosenstein; Gail Long; Chris Warren; Walter Wright; and Mark Souther. My Cleveland State University graduate assistant Nat Neider provided essential help, including photographing many Tremont sites. Nat was first introduced to Tremont in the early '90s as a teenager finding the Civilization coffeehouse. He later frequented other Tremont venues. More photographs by Matthew Ginn, another graduate assistant, were extremely timely. Mark Salling at Cleveland State University's Levin College provided the Tremont maps. Greg Dumais, Hannah Cassilly and Ryan Finn, my editors at The History Press, shepherded the manuscript through its evolution.

INTRODUCTION

Perched atop a bluff on the west side of the Cuyahoga River, overlooking what would later become Cleveland's industrial valley (the Flats), the area now known as Tremont was first settled in 1818 by two New Englanders: Seth Branch and Martin Kellogg. Through 1850, this area had few additional settlers. Its location was on the fringe of Ohio City, which was in competition with the city of Cleveland across the Cuyahoga River for commercial preeminence. Over almost two centuries, this area would undergo major changes, including its name—first Cleveland Heights (not to be confused with the east side suburb of the same name), then University Heights, Lincoln Heights, the South Side and now, for most residents, Tremont. In 1836, Ohio City and Cleveland residents fought over a river crossing, but in 1854, voters of both cities approved the annexation of Ohio City by the city of Cleveland. This neighborhood immediately to the west of downtown Cleveland retained the name Ohio City (and has also been called the "Near West Side"). In August 1867, the area now known as Tremont was also annexed by the city of Cleveland.

The name University Heights came about in 1850 when Mrs. Thirza Pelton and John Jennings decided that the heart of the Tremont neighborhood should become the site of a university. Mrs. Pelton was the primary promoter of this project. Thirza and her husband, Brewster, came to the area from Oberlin, where they ran a boardinghouse for students at Oberlin College. New England investors provided the funding to purchase a 275-acre parcel from the son of Seth Branch, one of the original settlers

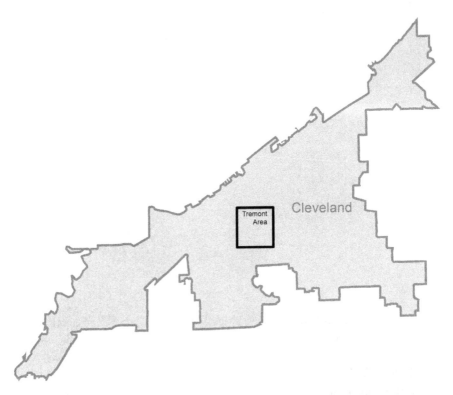

Map of Cleveland and Tremont. *Courtesy of Mark Salling, Levin College, Cleveland State University.*

in the area. The Peltons would name it Cleveland University, although it was envisioned to be a national university modeled on Brown University in Providence, Rhode Island. The campus plan called for a classroom building, an orphan asylum, a female seminary and an old age home. Much of the rest of the parcel was to be sold to finance an endowment for the university.

The Peltons recruited Dr. Asa Mahan, then the president of Oberlin College, to become president of this new university. Mahan was a controversial educator embroiled in disputes with the some of the trustees and faculty at Oberlin College. He was a minister who moved from Rochester, New York, to Cincinnati in 1831 to become pastor of a Presbyterian church. An outspoken abolitionist, his views while on the board of Cincinnati's Lane Seminary resulted in his departure in 1835 to become president of the new Oberlin College, renowned for being both the first coeducational college in the United States and also a school that admitted students of color. Mahan brought Oberlin College students and some of the Oberlin College faculty to Cleveland. They agreed to teach at this new Cleveland University. Mahan

published the following description in the *Cleveland Plain Dealer* on October 23, 1850, of the site of this planned university: "Can you conceive of a site more beautiful or better located relative to the city and where the most enchanting walks, drives, arbors and foundations around the institution can be easily formed than at this very spot before us?"

However, this educational experiment did not last long. Mrs. Pelton died in 1853 and, with her, the university. It closed after graduating only eleven students. Mahan went on to other pastorates and then to the presidency of Adrian College in Michigan. He became a leader in the Divine Faith Healing movement. The legacy of the failed university that he and Thirza Pelton left behind was the neighborhood's name of University Heights, as

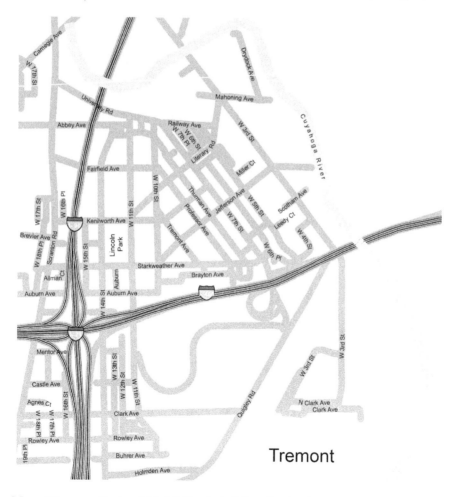

Map of Tremont. *Courtesy of Mark Salling, Levin College, Cleveland State University.*

well as streets named College Avenue, Professor Street, University Road and Literary Road. The buildings constructed for the university were later sold for the educational Humiston Institute, which was later sold to become the Cleveland Homeopathic Hospital College.

The widower Brewster Pelton maintained part of the campus site as a private park. In a forerunner of community action that would later characterize the residents of the Tremont neighborhood, University Heights residents demanded that Pelton open the park to the public and repeatedly tore down the fence that surrounded it, according to the July 11, 2004 *Plain Dealer* article "In Tremont, Lincoln Park Was Always the Peoples Park." After his death in 1872, the City of Cleveland unsuccessfully tried to take over control of the park. In 1879, however, the city purchased the park (renamed the South Side Park), and the fence was removed permanently. In 1896 (Cleveland's centennial), the park was renamed Lincoln Park to honor both the president and the memory of Camp Cleveland, an area in Tremont used for recruitment and training of more than fifteen thousand Union soldiers. A military hospital was also located at Camp Cleveland during the Civil War. In more recent times, Civil War reenactments have been held in Tremont to commemorate Camp Cleveland, and an Ohio Historical Marker was erected on its site in October 2003. In recognition of this heritage, University Heights became known as Lincoln Heights. Later in the nineteenth century, residents came to call it the "South Side."

In 1859, the settlers established the area's first church, the University Heights Congregational Church. The founders included Brewster Pelton, John Jennings and Ransom Humiston. In 1864, the congregation, after holding its assemblies in the Humiston Institute building, decided to build the Jennings Avenue (named after John Jennings, later West Fourteenth Street) Congregationalist Church across from Pelton Park. The church building was completed in 1869 and formally dedicated in 1870. Many other churches would follow in Tremont.

INDUSTRIALIZATION

The period during and after the Civil War saw the rise of Cleveland as a manufacturing metropolis. Leading sectors were shipping, the iron and coal industries, chemicals and the incipient refining of oil. With the advent of the railroad and the proximity of raw materials accessible via Great Lakes shipping and the railroads, Cleveland was poised to become a major industrial city. The time from the 1860s to the 1870s saw manufacturing jobs more than double. The population also doubled. An example of this growth was the firm of Lamson and Sessions, founded in 1866 in Hartford, Connecticut, as a producer of nuts and bolts. As the company grew, the owners decided to head to the Western Reserve (Ohio), along with their employees (the group was known as the "Connecticut Colony"). The company located on Scranton Road in Lincoln Heights in 1869, where it prospered.

It continues as a diversified manufacturer today, though headquartered now in the Cleveland suburb of Beachwood. Isaac Porter Lamson and Samuel W. Sessions built mansions along Jennings Avenue, where they were joined by other wealthy residents. Jennings Avenue preceded the Millionaires Row along Euclid Avenue in downtown Cleveland as home to wealthy business owners. A few of those mansions have survived along the since renamed West Fourteenth Street. The location of factories along the Cuyahoga River in the industrial valley, or "Flats," at the base of Lincoln Heights drew immigrant labor from Europe in growing numbers.

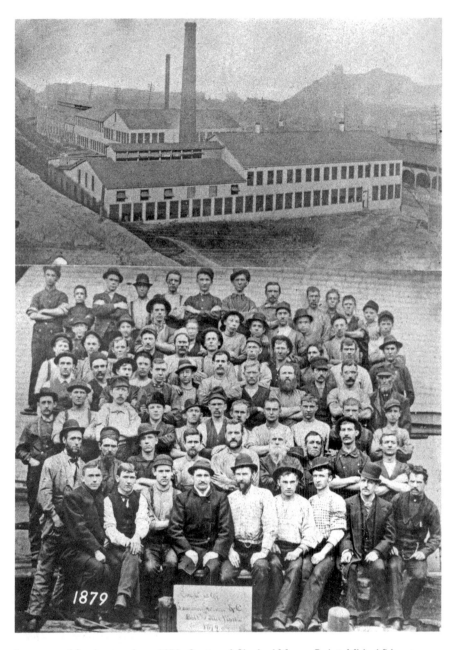

Lamson and Sessions workers, 1879. *Courtesy of Cleveland Memory Project, Michael Schwartz Library, Cleveland State University.*

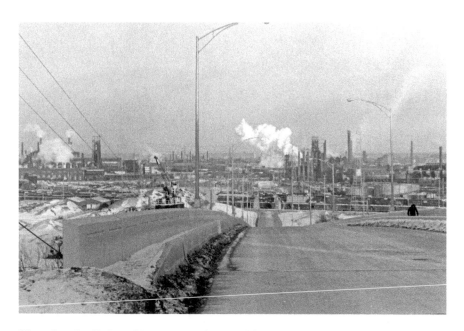

View of steel mills from Clark Avenue. *Courtesy of Cleveland Memory Project, Michael Schwartz Library, Cleveland State University.*

German and then Irish immigrants had previously been the first European nationality groups that contributed to Cleveland's growth.

IMMIGRATION

The rapid growth of the industrial city fueled even more foreign immigration up until the outbreak of the First World War in 1914. Immigrants, mostly from Europe, poured into Cleveland and formed ethnic villages. Germans were among the first European groups to immigrate to Cleveland. In an October 19, 2003 Tremont Oral History interview, Robin Schloss remembered her family's Tremont roots. Her grandfather, great-grandparents and great-great-grandparents with roots in Germany and West Prussia lived in Tremont. Some worked for the railroad, while her ancestor Louis Goebbels arrived in the United States in 1867 and opened a tavern on Professor Street that he owned for three decades. Asked about the changes in Tremont, Schloss replied:

> *The only opinion that I could form is that going back to the 1866 mode, 1870s, to the addresses where they lived, if they lived in frame homes, which I'm sure they did, the homes that stand there now, are probably not the original homes, so I could not kind of relate to that. Nothing lasts forever. There is one building down there where the tavern was* [2442 Professor] *that belongs to some Polish legion organization* [Polish Legion, American Veterans, Roosevelt Post No. 58] *now, that I think might be the original building, and I feel good about it. I feel good that something has survived all these years. And there's another house on Starkweather that my great-grandfather had lived in that is still standing, which gives me kind of a good feeling too, to know*

it's still there and not bulldozed or removed because of the freeway coming through there.

Due to its location, Lincoln Heights (or the South Side) became a magnet for many of these immigrant groups due to its proximity to heavy industry in the adjacent Flats along the Cuyahoga River. The Slavs were most noticeable among the many immigrants drawn to Lincoln Heights. Among the West Slavs were the Polish and Slovaks and among the East Slavs the Greater Russians, Carpatho-Rusyns, Ruthenians, Lemkos and Ukrainians. Many of the East Slavs came from the Carpathian Mountains region of what was part of the Austro-Hungarian empire until it was dissolved after World War I. The Lemkos came from an area known as Lemkovia in the Carpathians. The Slavs were joined by some Greeks, moving west from their original location east of the Cuyahoga. These many immigrant arrivals were housed in dense workers' housing, often two or three buildings on a single lot (some surviving even now). Between 1900 and 1910, Cleveland's population grew from 381,768 to 560,663, making it the sixth-largest city in the United States. Of the 1910 population, 196,170 were foreign born, with 57 percent of those representing new immigrants. Within a century, this area had been transformed from bucolic farmland first pioneered by Protestant New Englanders into a teeming, multicultural village of mostly poor industrial workers from many European countries speaking many different languages and adhering to many different religious faiths. In a February 22, 2003 Tremont Oral History interview, Edward Mendyka, whose father emigrated from Poland in 1910 and whose mother cleaned Cleveland public schools, remembered:

> [O]*ur home language was Polish. Everything was in Polish, and as far as that goes, you could spend your whole lifetime in that neighborhood; we had Polish neighbors, and we went to a Polish church. Polish school, Polish parish, so you know, you could have spent your whole lifetime in that neighborhood and you didn't need to know that much English.*

CHURCHES

These mostly poor European immigrants to Cleveland pooled their meager resources to build churches in what had become Lincoln Heights just as the Congregationalists had before them in what was then called University Heights. The first example was the decision of the Irish to build a church on Jennings Avenue in 1860, having previously worshipped at St. Patrick's Church in Ohio City. When Pilgrim Congregational decided in 1892 to build a new, larger church, it sold its original building to the Catholic Diocese of Cleveland to house the St. Augustine parish. The new Pilgrim Congregational Church on West Fourteenth Street at Starkweather Avenue was dedicated in 1894. The Irish were followed in 1865 by the Germans, who built the Emmanuel Evangelical United Brethren Church. The churches of the Irish and the Germans would be followed by a profusion of churches of many faiths, eventually totaling more than two dozen churches in this small, compact community. In a May 20, 1984 article entitled "Tremont's Skyline Praises the Lord," the *Plain Dealer*'s architecture critic Wilma Salisbury wrote:

> *The fascinating church-dominated fabric of Tremont symbolizes the failure of the melting pot idea in America. Although dozens of ethnic groups converged on this once densely populated area, they did not merge into a homogeneous community. Rather, each group clung to its own culture and clustered in the shadow of the neighborhood church, which tended to be structured and decorated after a model in the old country.*

The number of churches constructed in such a small neighborhood makes Tremont unique not only among Cleveland neighborhoods but also generally among urban neighborhoods. Over time, with the arrival of new immigrant groups (e.g., Hispanics), some of these churches have been converted to use by other faiths. One example is Iglesia Pentecostal El Cavario Church. Its building at West Fourteenth and Starkweather was originally that of Emmanuel Evangelical United Brethren, which sold it to the Cleveland Baptist Temple in 1968. In turn, it sold the church in 1998 to Calvary Pentecostal. Some congregations have seen a substantial loss of resident members because of the exodus out of the neighborhood in recent decades, although many former residents continue to return for services. With the decline of the population of Tremont, some of these churches have been closed and been repurposed. The following are profiles of some of the many churches of Tremont.

PILGRIM CONGREGATIONAL CHURCH

As previously mentioned, Pilgrim Congregational is Tremont's oldest church. Formed by thirty-four charter members in 1859 as the University Heights Congregational Church (UHCC), its first building was completed in 1869 and dedicated in 1870. The Connecticut Colony arrived at the same time, and the two Lamson brothers (Thomas and Isaac) and Samuel Sessions provided support for the church. The UHCC women organized a Ladies' Aid Society/ Women's Association and joined the Woman's Christian Temperance Union (WCTU), which held its national convention in Cleveland in 1874. The church also supported the Anti-Saloon League. They opened one of Cleveland's Friendly Inns, which were liquor-free gathering places, especially for the poor. They also organized a sewing school. In 1877, the Ladies Benevolent Union was formed to fundraise for mission work. That same year, the church made a major change in its fundraising for its operation. This had been done by the rental of pews. The most prominent financial supporters, including Isaac Lamson, decided to release their seats so that anyone could occupy any empty seat—a major change.

With the arrival in 1891 of a new pastor, Charles Smith Mills, the church adopted another major change in its mission. Mills advocated the idea of the "institutional church," which beginning in the 1870s embraced a "city mission." Mills suggested three key characteristics of the institutional church:

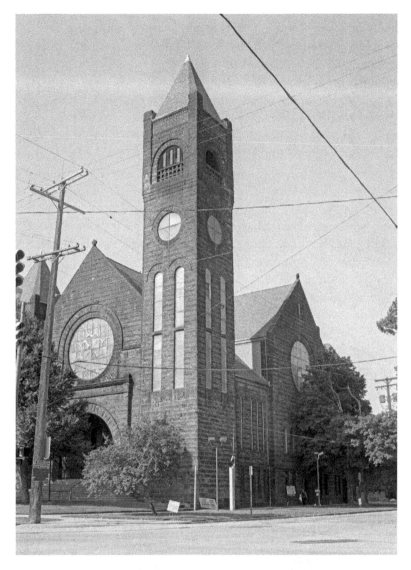

Pilgrim Congregational Church. *Photo by Matthew Ginn (www.MatthewGinn.com).*

1) open doors (constant access); 2) free pews; and 3) evangelism. This was in part a reaction to the changing makeup of the population of Tremont with the arrival of the thousands of immigrants seeking work in Cleveland's Flats. This, in turn, led to the construction of a new and larger church building. Ground was broken in 1893, and the new church was dedicated in 1894. The building was constructed in a Romanesque architectural style, and

the layout was known as the "Akron Plan." Its facilities included a Sunday school, an auditorium, a gym, a stained-glass dome and a bell tower. In 1893, Abigail Lamson Olney, the widow of Thomas Lamson, now married to Charles Olney, donated a pipe organ to honor her late first husband. She also donated a stained-glass window in his honor, as did Samuel Sessions in honor of his late son. This new building now housed the Pilgrim Congregational Church, the name change having been adopted in 1892.

As an institutional church, it formed the Pilgrim Institute. It offered broad access not only to its members but also to neighborhood residents in the use of its gym, library, educational and industrial classes, kindergarten (funded by Mrs. Olney) and sewing school. In 1903, a visiting nurse was added to the staff with the help of the Visiting Nurses Association of Cleveland. In 1920, a Pilgrim Home Making and Nutrition Center was established. That same year, the Men's Club financed and opened a Community House, which included a popular bowling alley. Eventually, the bowling alley was no longer used and was finally eliminated in the 1990s during a remodeling.

Mills departed in 1905 for another Pilgrim Church in St. Louis (in part due to his family's health problems). He was succeeded as pastor by Dan Freeman Bradley, who served until 1937, when he retired at the age of eighty. Bradley graduated from Oberlin College, as had his mother and his three older brothers. In 1957, then pastor Ludwig Christian Emigholz (who had arrived in 1950) noted the changing nature of Tremont, echoed by the chair of Pilgrim's 100th Anniversary Fund Campaign:

> *Ten years ago we decided to stay and serve here rather than follow the parade of churches to the suburbs. We keep our doors open seven days a week in an area of need. We are the only Protestant church with a full-time program: serving youth in a troubled district, winning new members for a free Protestant church in an area dominated by five large Roman Catholic churches.*

Pilgrim welcomed other Tremont church groups to use its facilities and helped the Puerto Rican population establish its own church. Church members were active in the civil rights movement of the 1960s. Pilgrim continued to reach out to youth. As a member of the Tremont Churches Community Center, it helped establish the short-lived (1967–69) Cup coffeehouse. However, for all of its outreach efforts, from a peak membership of 1,297 in 1924, its membership fell to only 161 in 1989. Nevertheless, pastor Laurinda Hafner, who arrived in 1990 and served until 2006, led new efforts to continue Pilgrim as an institutional church. In 1993, it became the first

Cleveland-area United Church of Christ (UCC) to declare itself to be "open and affirming," welcoming the LGBT population. The congregational vote on this policy was sixty-nine for and twenty-four against. One consequence of this decision was the loss of its Boy Scout Troop 98 after ninety years. Pilgrim then responded by joining Scouting for All. Pilgrim continues to offer social services and hosts Arts Renaissance Tremont concerts.

ZION UNITED CHURCH OF CHRIST

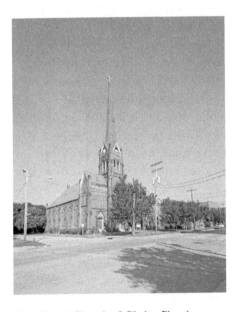

Zion United Church of Christ. *Photo by Matthew Ginn (www.MatthewGinn.com).*

This church, founded by German immigrants, traces its origin in Tremont to May 1867, when a cornerstone for its first church was laid at the corner of College Avenue and Tremont Street. In 1872, an expansion led to a move to its present site on West Fourteenth Street. In 1874, the church joined the German Evangelical Synod of North America. A new church building was constructed on the site in 1884. The first service in English was introduced in 1916. In 1927, the church changed its name to Zion Evangelical Protestant Church. In the face of changes in the neighborhood, the membership twice voted against relocation, first in 1941 and again in 1963. In 1957, the church merged with the Congregational Christian churches to form the United Church of Christ, as did the Pilgrim Congregational Church. The national headquarters of the United Church of Christ is located in downtown Cleveland. By 2015, the Zion UCC church only had a tiny number of members.

ST. AUGUSTINE ROMAN CATHOLIC CHURCH

Irish immigrants living in University Heights originally attended mass at St. Patrick's in Ohio City, but they appealed to Cleveland's first Roman Catholic bishop for a church of their own. Their wish was granted in 1860, and a church was built at the corner of Tremont and Jefferson. The parish's first full-time pastor arrived from France in 1867. A school was started in 1868. Pastor Charles Grandmougin died in 1871 during a smallpox epidemic.

In 1895, with the growth of the congregation, the St. Augustine parish bought the Victorian Gothic church of Pilgrim Congregational when Pilgrim moved to its new church building. A new school was built in 1908 and remained open until 1964. That same year, Reverend John Wilson was a key figure in persuading the Ohio Department of Transportation to reroute the construction of I-71 in order to save St. Augustine and several other Tremont churches along West Fourteenth Street from being destroyed to make way for the highway. These churches and other buildings along West Fourteenth Street were described in the April 30, 2000 *Plain Dealer* article "Tarnished but Still a Jewel." In 1964, under the leadership of Reverend Joe McNulty, St. Augustine became the Pastoral Center of the Catholic Deaf Community. Sister Corita Ambro arrived in 1970 to work with the deaf. The church also reached out to the disabled. Father McNulty, who became pastor in 1972, came to be called the "Pope of Tremont." In 1977, St. Augustine became the Pastoral Center for the Catholic Blind Community. In 1990, a ministry for the mentally ill was added to the apostolate, and the Byzantine Catholic School was converted into a school for the mentally disabled (OLA St. Joseph's Center).

Sister Corita and Reverend McNulty were responsible for the Hunger Center, which began as a local soup kitchen and expanded to serve the Cleveland community, not just Tremont. It hosts thousands on major holidays like Thanksgiving and Easter. Through her continued dedication to the poor, Sister Corita became known as the "Mother Teresa of Tremont" and the "Angel of Tremont," according to the *Plain Dealer* of December 29, 2008. On May 14, 2001, they were both honored during a visit by President George W. Bush, who was promoting his federal faith-based initiative for social services. On November 2, 2008, there was a local celebration of the Cleveland City Council's designation of the northwest corner of the intersection of West Fourteenth Street and Howard Avenue as the "Father McNulty and Sister Corita Corner."

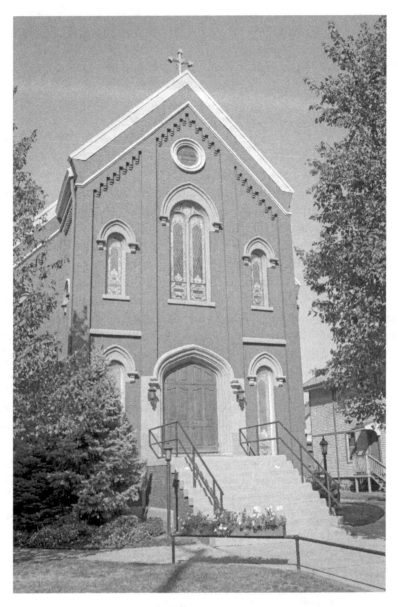

St. Augustine Roman Catholic Church. *Photo by Matthew Ginn (www. MatthewGinn.com).*

In 1979, the Catholic Korean Community came to Tremont and was housed at St. Augustine until 1988, when the nearby St. Andrew Kim Church was opened in a former Polish National Catholic Church.

St. Theodosius Russian Orthodox Cathedral

This is one of Tremont's iconic churches, both for its striking appearance and its role as the venue for the wedding scene in the movie *The Deer Hunter*. It was founded in 1896 by a group of Carpatho-Rusyn immigrants called the St. Nicholas Society. The Rusyns who immigrated to Tremont came primarily from areas of Poland, Slovakia and Ukraine, many of them Lemkos from the Carpathian Mountains region. They first had a church building at the corner of Literary Road and West Sixth Street. Then, in 1911, the expanding parish decided to build the existing church (with the Russian czar Nicholas II said to have contributed financially to its construction cost as Russia and Austria-Hungary competed for the allegiance of the Rusyns). The cathedral was built on the Greek cross plan, with the central onion dome representing Jesus and the twelve smaller cupolas surrounding it representing the twelve Apostles. The building contains elements of both the Byzantine and Romanesque styles. It was modeled after the Church of the Saviour Jesus Christ in Moscow. Father Jason Keppanadze was the pastor from 1922 to 1957.

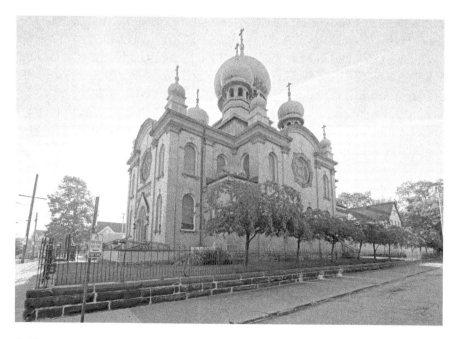

St. Theodosius Russian Orthodox Cathedral. *Photo by Matthew Ginn (www.MatthewGinn.com).*

ST. JOHN CANTIUS CHURCH

The late nineteenth century saw eastern European Slavs migrating to Cleveland in larger numbers. The number of Polish immigrants grew in the 1870s, settling in what became known as Warszawa (later Slavic Village). By 1894, there were four Polish Roman Catholic parishes east of the Cuyahoga River. As Poles began to move west across the river, enough had moved to Tremont for them to petition the Catholic Diocese of Cleveland to establish their own parish.

With the approval of the bishop and the arrival of a priest born in Russian Poland, a car barn at the corner of Professor and College was converted into the first St. John Cantius Church and school in 1899. With a growing congregation, a new church and school were constructed on the site from 1909 to 1913. The year 1917 saw the arrival of a new Polish-born pastor, Joseph Kocinski, as well as conflict. His predecessor had warned the bishop against the appointment. The controversy revolved around competition from the nearby Polish National Catholic Church. This led to a call in 1925 for Kocinski's removal. Among the charges was a loss of families to this religious competitor. However, the bishop sided with Kocinski. This dispute resurfaced in 1932, when hundreds of parishioners again called for the bishop to remove Kocinski. This time, protesters blocked Kocinski for weeks from entering the church. The police had to be called on to maintain the peace. Kocinski blamed all of this on Communists. Finally, in May 1932, the bishop reassigned Kocinski to an East Side Polish parish. In the midst of these conflicts, Kocinski managed to preside over the construction of a new church/school, dedicated in 1926.

By the time of the death of his successor in 1939, the congregation of St. John Cantius was second only in number to St. Stanislaus in Slavic Village. It would peak in 1949 with an enrollment of two thousand families. In 1950, a new high school and recreation center building were dedicated. The year 1952 brought incidents of police raids on St. John Cantius for serving wine and beer in the bowling alley in the recreation center and at the parish carnival, finally leading to its priest giving up its license to serve alcohol. This was followed by a police raid against parish women playing a version of bingo to raise money for the school's Christmas party. Despite the illegality of bingo games, the county prosecutor refused to charge the women.

In 1956, the first pastor not born in Poland arrived. During the next seventeen years, he (and then his Cleveland-born successor) would preside over a marked decline in the congregation and enrollment in the church's school. In a February 22, 2003 Tremont Oral History interview, Eddie Bugala, whose Polish parents immigrated to the United States in 1899, noted:

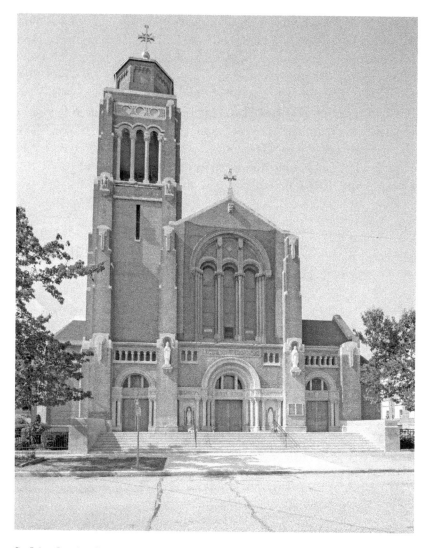

St. John Cantius Church. *Photo by Matthew Ginn (www.MatthewGinn.com).*

[T]*hen they built a church that's standing there on the corner of Professor and College. That's a big church. That's a big large church there. Then, like I say, they had a big congregation. They had about four different masses on a Sunday. If you went there, you had to be there on time, or otherwise you were standing in the aisles or in the back of the church. That's the kind of congregation they had at that time. Today, if you go in there, they're lucky if they get one hundred people.*

At one time, Tremont had several other Polish institutions, like Polonia Hall on Professor, which had a dance hall, and the Polish Library Home on Kenilworth, which housed both a Polish-language library and a bar and hall. A surviving example is the Domagalski Komorowski funeral home at 2258 Professor Street near St. John Cantius Church. It was founded in 1951 by Edward Domagalski. In 1991, the Komorowski family, who started their funeral home in 1939 in the Slavic Village neighborhood, bought the Tremont funeral home. There are also two posts of the Polish Legion, American Veterans, in Tremont: the Pulaski Post No. 30 and the Roosevelt Post No. 58.

Sts. Peter and Paul Ukrainian Catholic Church (Greek Catholic)

The Brotherhood of Sts. Peter and Paul was founded in 1902. It was a branch of the Ruthenian National Association. Construction of the existing church began in 1910. After World II, two parish schools and a new convent for the Sisters of Basil were constructed. The bell tower topped by a semicircular form and Greek-style cross reflects a Ukrainian heritage. It is known as the mother church of other Ukrainian churches in Greater Cleveland (two in the western suburb of Parma). In a March 6, 2003 Tremont Oral History interview, Olga Bigadza Naugle (whose parents were immigrants) recalled:

Of course, I went to the Ukrainian dancing school as I told you. It was on West 14th street, the Ukrainian National Home. We used to go dancing in the public auditorium. My father was a violinist, and he had a little orchestra, and he played the Ukrainian music for us at that time. That I remember specifically. We sang songs in the church choir; it was a Ukrainian choir. Of course we could speak Ukrainian and we could read it. And at Christmas time we would go caroling to people's homes that wanted us to sing; you know they would request that we would come to their homes. They would serve us refreshments, cookies; they were so appreciative of us coming and singing. Then they would donate money to our church. We looked forward to singing these Ukrainian carols.

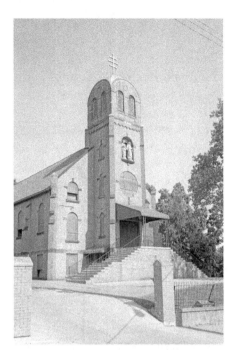

Right: Sts. Peter and Paul Ukrainian Catholic Church. *Photo by Matthew Ginn (www.MatthewGinn.com).*

Below: Sts. Peter and Paul Church and Ukrainian immigrants, Easter 1917. *Courtesy of Ukrainian Museum-Archives.*

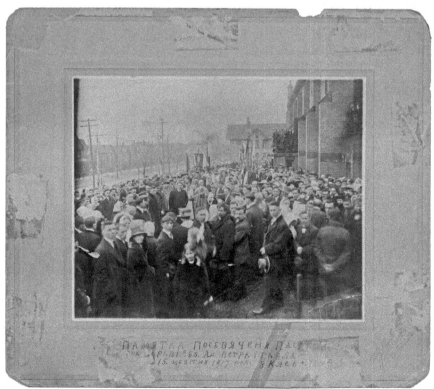

St. Wendelin Church

The first wave of Slovak immigration to the United States came in the decades between 1870 and 1890. Those who came to Cleveland were typically peasant farmers looking for work in the city's industrials plants, shops and foundries. These immigrants formed the First Catholic Slovak Union and the First Catholic Slovak Ladies Union. In 1907, a National Slovak Congress was convened in Cleveland to protest their oppression by the Austro-Hungarian empire. This led to the formation of the Slovak League of America. The Slovaks (and Czechs) initially settled east of the Cuyahoga, and three Slovak Catholic churches were located there.

The Slovaks then also settled in Lincoln Heights, and in 1903, they were granted permission to build a church there, which was named St. Wendelin. It was flanked by a brewery and a saloon. In 1924, the site of the pastor's and sisters' homes was sold to the Van Sweringen brothers (the developers of the Terminal Tower on Public Square and the planned suburb of Shaker Heights). With the sales proceeds, a new church and school were built on its present site on Columbus Avenue. St. Wendelin became Cleveland's largest Slovak Catholic congregation. As with many other Cleveland churches, the congregation dwindled along with the population decline in the city and in the Tremont neighborhood.

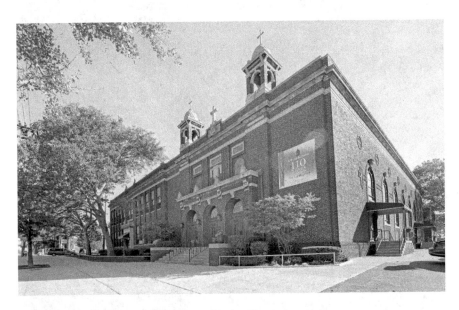

St. Wendelin. *Photo by Matthew Ginn (www.MatthewGinn.com).*

In 2009, the Catholic diocese ordered the closing of fifty churches, citing financial problems due to the decline in their congregations and a shortage of priests. Many parishioners protested these closings, and eleven churches appealed to the Vatican to reverse their closings. One of these was St. Wendelin. These appeals succeeded, and in July 2012, St. Wendelin reopened.

HOLY GHOST GREEK/BYZANTINE CATHOLIC CHURCH

Another group of immigrants fleeing the Austro-Hungarian empire were the Rusyns from the Carpathian Mountains. Their religious heritage was Byzantine Catholic, and unlike the Orthodox, they recognized the Roman Catholic pope as head of the church. In 1909, a Greek Catholic/Byzantine church was chartered for the Tremont neighborhood. The Holy Ghost Church, located across West Fourteenth Street from Lincoln Park, was

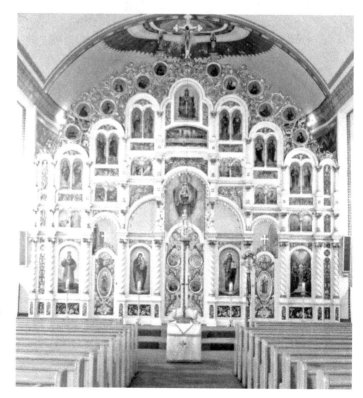

Interior of Holy Ghost Byzantine Church. *Courtesy of Cleveland Memory Project, Michael Schwartz Library, Cleveland State University.*

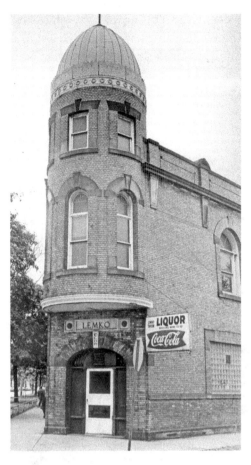

Lemko Tavern in Tremont. *Courtesy of Cleveland Memory Project, Michael Schwartz Library, Cleveland State University.*

dedicated in 1910. Joseph Hanulya was appointed pastor in 1918 and served until his death in 1962. A church school was dedicated in 1958. However, the school site was sold to fund a new church, which was dedicated in 1969 in the western suburb of Parma, where many former parishioners now lived. Due to a dwindling congregation, the Holy Ghost Church was closed by the eparchy (diocese) in 2009 and is now the Byzantine Catholic Cultural Center. It contains a ninety-year-old Hungarian icon screen (iconostasis) that has been undergoing restoration.

Of the Rusyns, many were Lemkos, and Cleveland would become second only to New York City as a center of Lemko culture, centered in Lemko Hall.

ISOLATED AND CONNECTED

Tremont was a geographically isolated area from its earliest settlement by the farmers from New England. With its growth in the late nineteenth century, its residents wanted a more direct connection to downtown Cleveland rather than having to travel through Ohio City. In 1879, James Curtiss, the South Side's city council member, asked the city's engineer to locate a crossing over the Cuyahoga River by a south viaduct (a north viaduct having previously been built at Superior Avenue). Construction began in April 1886, and the viaduct was opened on December 11, 1888. Two workers were killed during its construction. Named the Central Viaduct, it consisted of two bridges. The first was a "stilt" bridge with a series of twenty spans supported by stone piers connecting Central Avenue in downtown Cleveland to Jennings Avenue in Tremont. The second bridge over Walworth Run connected Abbey Avenue with Lorain Avenue near the current site of the West Side Market in Ohio City. At the dedication banquet of the Central Viaduct, journalist William R. Rose produced the following composition:

> *Our children's children tell*
> *The famous stories of the past—*
> *The tales they love so well—*
> *"In coming generations when*
> *With cheering and with laughter*
> *One deed they'll keep alive,*
> *How well brave Curtiss saved his bridge*
> *In eighteen eighty-five."*

The Central Viaduct provided the most direct connection from Tremont to downtown Cleveland. While cars and streetcars would provide passage, many of the South Side's poor immigrants walked to downtown, just as they walked to the West Side public market at West Twenty-fifth Street and Lorain Avenue after it opened in 1912. In an October 30, 2003 Tremont Oral History interview, Mollie Alstott remembered:

> [T]*hat whole area, Tremont area, was almost like a little village, because you didn't have to leave it except maybe for in cases like you wanted to go downtown or to the West Side Market and that was close enough. People, actually people walked there...I and with our mutual friends this time, one of the biggest thrills was to walk across the old central viaduct which is gone. So it was 14th all the way across the flats to downtown.*

The Central Viaduct had a pivoting center span resting on a turntable in order to allow river shipping traffic to pass through. It would play a tragic role on November 16, 1895. Electrically driven streetcars were replacing horse-drawn carriages. The Cleveland Electric Railway (known as "Big Con") carried passengers across the Central Viaduct. In late 1892, yet another tragic accident had occurred when two streetcars crossing the viaduct collided and many passengers were killed and injured. During mid-November 1895, the cut-off switch that would divert streetcars if the pivoting center draw was open shorted out and was not working. On the evening of November 16, a tug towing a lumber barge required the opening of the draw. At that time, an electric streetcar approached and was told to proceed until the officer in charge of the draw realized that the streetcar was headed for the gate and the draw; he was unable to halt the streetcar in time. It plunged off the viaduct into the Cuyahoga River, although a few of the passengers jumped off before it went over the open draw. The bodies of sixteen dead passengers were pulled from the river in the next two days. Miraculously, one injured passenger survived the streetcar's fall. An inquest into the tragedy found no "Big Con" employees guilty of an unlawful act.

The tilt draw span was removed in 1912 and replaced by a truss bridge. After a fire in 1914 destroyed much of the viaduct, it was rebuilt. After the 1932 opening of the Lorain-Carnegie Bridge, the viaduct was closed. It was condemned in 1941 and razed during World War II. The physical isolation of Tremont and bridge closing issues would reappear decades later.

THE LIFE OF IMMIGRANTS
IN TREMONT

Mass immigration to the United States and urban neighborhoods like Tremont was largely curtailed by World I and, after it, by the passage of legislation in the 1920s that limited immigration. Those who had previously arrived to find work and housing in urban neighborhoods like those in Cleveland, close to industry and their children and relatives, generally lived in dense conditions close to nearby workplaces. Overcrowded housing and pollution from the nearby factories were typical. Those immigrants who were able to buy a home often built another house to the rear for either their relatives to live in or to rent to supplement their income. In a March 20, 2003 Tremont Oral History interview, Robert Ceccarelli recalled this happening in his own family (of Polish and Ukrainian heritage): "[T]here was a lot of houses built with another house behind it. And they always rented or they had like boarding rooms like the houses were big...a lot of the houses were pretty big so inside those houses they had a lot of bedrooms...to rent out to boarders. There was a lot of that in that neighborhood."

All too many of the immigrants lived in poverty due to low wages. Without a governmental safety net, churches like those described previously and social service agencies like the Merrick House settlement provided some help to those in need. Also, there were mutual aid societies, lodges and national associations that provided aid to residents. This was especially critical in hard times such as during the Great Depression. In 1934, 36 percent of Tremont's labor force was unemployed.

Life in Tremont was described in detail in a 1936 report entitled *Between Spires and Stacks* by Charles Hendry, an academic sociologist, and Margaret Svendson, a social worker, both from Chicago. They were hired by the Welfare Federation of Cleveland to survey the people of Tremont and their living conditions in the midst of the Great Depression. Their data and impressions paint a broad picture of Tremont in this era:

> *One's first impressions of the South Side, as the Tremont Area is commonly called, is one of spires and smokestacks. Certainly these two elements, symbolic on the one hand of a Central European peasant culture and on the other of American industrialism, are the dominant features in a bird's eye view of the Area, either from the Central Viaduct to the north west or from the more distant Clark Avenue Bridge to the south. One wonders as he looks out across the Cuyahoga Valley with its maze of railroad tracks and its belching furnaces, and as he contemplates the massive yet majestic cupolas of the St. Theodosius Russian Orthodox Church, silhouetted against the sky high on the eighty foot bluff that marks the site of this study, how harmonious is the blending of these two sets of culture.*

The investigators traced the transition from University Heights to the South Side:

> *And so today as one enters this one-time privileged Area settled by New Englanders and followed in turn by Irish and Germans, later by Northern Slavs and more recently Southern Europeans, one finds himself in an Area of transition, an Area in which the strains and stresses of conflict and adjustment are severe and symbolic, an Area whose name itself, the South Side, has come to be associated with gangsters, hoodlums and underprivileged. In the cycle of one century the Area has moved from the splendid isolation of privilege to the submerged isolation of poverty. University Heights has become the South Side.*

The South Side's population in 1934 was reported to be 15,026 residents, one-third (4,981) of whom were foreign born. The predominant nationality of this foreign-born population was Polish (2,006), followed by Ukrainian (978), Slovak (703) and Russian (665). The small remaining number traced their national heritage to Greece, Germany, Italy, Syria and fifteen other European countries. About three quarters (76.7 percent) of the 3,375 families had heads who were foreign-born. Most of the foreign-born arrived

before the beginning of World War I in 1914, and of those 40 percent came in the years 1910–14:

> *The notable absence of conversation in English, the character of the names upon store fronts, the frequency with which one comes upon foreign language posters and announcements, the dominance of cupolas and the triple cross of the Greek Catholic Church upon the skyline, the occurrence of national homes and the appearance of foreign language newspapers, all emphasize the immigrant character of the Area.*

The investigators paid homage to the cultural heritage of Tremont's immigrants. They pointed to annual festivals (especially at Christmas and Easter celebrations), handicrafts, church choirs and folk dances.

On the negative side, in addition to noting the widespread poverty of Tremont's population, the health problems that they faced and their substandard housing, the investigators also wrote, "The Tremont Area has acquired a reputation which brands it as a tough area." They cited police and Juvenile Court reports about high rates of crime and juvenile delinquency. Edward Mendyka objected to this portrait of Tremont:

> *It was, like, you know, you can't go in that area, because you're liable to get mugged or hurt or whatever. If you were born and raised there you never had any problems, you know. You were part of the crowd. And there were all kinds of nationalities. Polish, Ukrainian, Greek, Slovak and Russian and somehow or another, you know, everybody was concerned about making a living and raising their family. That's what they did.*

The most notorious example of the neighborhood's criminal reputation was Joe Filkowski, known variously as the "Phantom of the South Side," the "Jefferson Hill Tough" the "Sheik of Literary Avenue," "Smiling Joe" and the "Powder-Puff Bandit." He was one of thirteen children growing up in the Jefferson Avenue/West Fifth areas of Tremont. His father was killed in a lumberyard accident, and his stepfather committed suicide. Joe's criminal career began at age fifteen in 1914, when he and his brother were arrested for stealing air rifles and ammunition from a neighborhood grocery store. Two years later, he was imprisoned in the Mansfield Reformatory for more thefts. He returned to the penitentiary in 1919 for auto theft. In 1924, Filkowski was accused by a bank security guard before he died of being the triggerman in a deadly robbery, but the grand jury did not indict Joe for murder.

After a stint in the Ohio Penitentiary, he formed the Flats Gang with two others and began a series of well-publicized crimes. On June 6, 1930, he killed a contractor in a bankroll holdup. The gang then committed several more robberies. To many in Tremont, Filkowski was a hero, not a murderous criminal. The Filkowski criminal legend grew after December 5, 1930. That day, George Kekic, the husband of Joe's fellow gangster's half sister, Mary Stazeki, found Filkowski making love to her. He then tipped the police about Joe's hideout on Jefferson. In a shootout the next night, Filkowski escaped. Over the next few days, the police killed one of Joe's gang and captured the third member. On October 17, 1931, Joe and George Kekic confronted each other in Kekic's Tremont home, where Filkowski was wounded in a shootout.

Filkowski departed for Chicago, where he was joined by Mary Kekic. After an attempted bank robbery in which Filkowski and another gangster disarmed two detectives, Filkowski and Mary fled to New York City. Two months later, Filkowski was captured there on West Forty-seventh Street in a sting operation by Cleveland and New York detectives. Mary Kekic was then arrested in possession of an arsenal of guns and ammunition and $100,000 in stolen diamonds. Kekic was imprisoned, and after a trial for the 1930 murder, Joe received a life sentence in the Ohio Penitentiary. Two attempts by Filkowski and other prisoners to escape in 1936 were foiled. With Mary Kekic's devoted advocacy on his behalf, Filkowski was finally released on April 15, 1963, and on July 6, 1963, they were married at St. John Cantius Church.

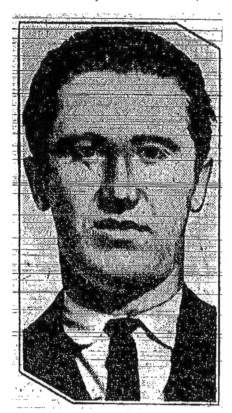

Joe Filkowski, 1930s Tremont gangster. *Courtesy of CSU Library Special Collections.*

Immigrant life in Depression-era Tremont was fictionalized by resident novelist Raymond DeCapite. His 1960 novel *The*

Coming of Fabrizze tells the tale of an Italian immigrant coming to America and the South Side in the 1920s, working first as a railroad laborer and eventually prospering, only to lose his accumulated wealth and that of his compatriots during the stock market crash of 1929 and then subsequently disappearing. For this first novel, DeCapite won the Cleveland Arts Prize for literature in 1962. DeCapite lived in the Tremont neighborhood for several decades with his mother and sister over a Greek coffeehouse. He died in 2009 at the age of eighty-four.

On May 18–19, 1991, a Tremont conference called A Celebration of 150 Years of an Urban Neighborhood was held at Pilgrim Congregational Church. Organized by Cleveland State University history professor David Goldberg, it focused on the ethnic and migrant groups that had come to Tremont. In Cleveland's Cultural Gardens, located in Rockefeller Park on the city's East Side, among the many ethnic/nationality gardens commemorating the groups that came to Cleveland are seven established in their early period reflecting European immigrants who settled in significant numbers in Tremont: German (1929), Slovak (1932), Polish (1934), Irish (1939), Rusyn (1939), Greek (1940) and Ukrainian (1940).

TREMONT INSTITUTIONS

In addition to Tremont's many churches, this neighborhood has several notable institutions. Five are profiled here.

CARNEGIE LIBRARIES

The steel industrialist Andrew Carnegie, as part of his philanthropy, funded the building of 1,679 public libraries in the United States, including 15 in Cleveland. Two of those are located in the Tremont neighborhood: the Jefferson Branch on Jefferson Avenue and the South Branch on Scranton Road. Builder and artist Ora Coltman's painting of Tremont viewed from the Clark Avenue Bridge hangs in the Jefferson branch library of the Cleveland Public Library (CPL). Its title was *A View of Tremont from the Clark Avenue Bridge [Little Russia]*.

Also displayed in the CPL Jefferson branch library is a painting entitled *Out of the Past, the Present, Out of the Material, the Spiritual*. It was painted during the Depression by Ambrozi Paliwoda through the WPA arts program. It shows a mass of Ukrainian peasants in a village square on their way to church and immigrant workers in the steel plants. Growing up in Tremont, Paliwoda was the son of a Ukrainian community leader who helped to build the Sts. Peter and Paul Church in Tremont.

The South Branch library was opened in 1897 in a rented building. It was then moved to Scranton Road in a Tudor-/Gothic-style building in 1911. By March 2013, this historic building was experiencing severe

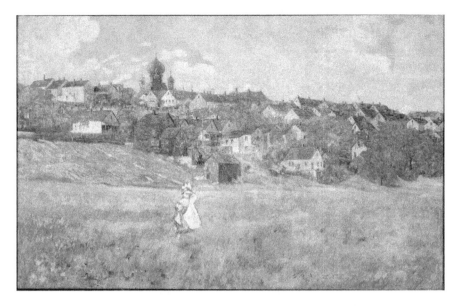

A View of Tremont from the Clark Avenue Bridge [Little Russia], Ora Coltman, 1926. *Courtesy of Cleveland Public Library, Jefferson Branch.*

Cleveland Public Carnegie South Branch Library. *Photo by Matthew Ginn (www. MatthewGinn.com).*

physical problems. The Cleveland Public Library replaced the roof but mothballed the building because of major deficiencies in its heating system that would require its remediation at an estimated cost of $3 million. The CPL then opened a temporary site nearby on Scranton Road.

Meanwhile, the CPL was beginning to develop a Vision Plan for its 150th anniversary in 2019. Fearing a possible permanent closure of this historic branch building if renovation proved to be too expensive, the Tremont West Development Corporation (TWDC) rallied residents to petition the CPL to keep a renovated South Branch building in operation. In May 2015, the Cleveland Urban Design Collaborative, hired by the CPL to conduct public meetings on the future of the CPL, surveyed residents about the future of the South Branch, following an initial public meeting in December 2014. Residents who were surveyed wanted the existing landmark building renovated and reopened. An advisory committee included two TWDC staffers and two Tremont residents. TWDC led a "Save the Library" campaign that succeeded in persuading the CPL to renovate this branch library.

Tremont Elementary School

The current Tremont Elementary School building dates back almost a century to 1917. It replaced the original school built several decades earlier. When it was built, it was said to be the largest elementary school building in the state of Ohio. The emergence of the name Tremont for the neighborhood, replacing Lincoln Heights and the South Side, is said to be due to the association with the school. With the decline in the population of the city of Cleveland and the Tremont neighborhood, the public school population also declined, leading to several closing threats by the school district.

The school was converted to a Montessori school in 2005. While this attracted more students, including many from outside the Tremont neighborhood, in 2010 it was again threatened with closure by the Cleveland Metropolitan School District (CMSD), which had also proposed its closing previously in 2002. Large numbers of Tremont residents, including many without school-age children, attended a public meeting to protest its closing. Their opposition carried the day, and the Friends of Tremont School was formed to support the school.

Despite the Tremont school's survival on these occasions, the fate of the building became an issue once again in 2014. As the CMSD considered which school buildings should be saved or replaced as part of a multi-year construction

Tremont School. *Photo by Matthew Ginn (www.MatthewGinn.com).*

program, it grouped the Tremont Montessori school in its Ohio City–Tremont Neighborhood Cluster of six K–8 elementary schools. The Tremont school had a student population of 584, which represented an increase of 12 percent over the previous five years. It had a very diverse student population: 64 percent black, 17 percent white, 12 percent Hispanic and 7 percent two or more races. With a grant from the Cleveland Foundation, TWDC, in partnership with the Friends of Tremont School and the administration of Tremont Montessori, is working to develop a strategic plan for the school (beyond the CMSD's yet-to-be-made "replace or renovate" decision about the building).

MERRICK HOUSE

Settlement houses appeared in poor neighborhoods in American cities beginning in the late nineteenth and early twentieth centuries. Modeled on similar agencies in English cities, they sought to improve the lives of the poor, especially immigrants working and living under often terrible conditions. Most were founded and staffed by volunteers, often the scions of wealthy families. Cleveland saw several neighborhood settlement houses founded on this model (e.g., Alta House in Little Italy, funded by John D. Rockefeller and named for his daughter).

The year 1919 saw the creation of another settlement house named Merrick House, located in the Tremont neighborhood. However, unlike its counterparts, it was funded through the National Catholic War Council. It was created as part of a post–World War I program using surplus funds from war relief, with the director of Cleveland's Catholic Charities playing an important role in their use. Merrick House consisted of a settlement house and a day nursery. It was named to honor Mary Merrick, founder of the National Christ Child Society. In 1949, it moved to its present building facing Lincoln Park.

In the 1936 report cited earlier, it was noted that Merrick House provided dozens of programs for Tremont's youth and that it assumed joint responsibility with Cleveland's board of education in the conduct of the Tremont School Community Center. But the same report cited Merrick House's inadequate equipment and meager facilities.

Approaching its 100th anniversary, Merrick House continues to serve the residents of Tremont. In 1979, it gave birth to the Tremont West Development Corporation. An influential figure in the history of Merrick House was its longtime director, Gail Long. Born in Hawaii, she obtained her master's degree in social work from Case Western Reserve University in 1967 and then worked as a community organizer and VISTA supervisor for the West Side Community House. She came to Merrick House in 1972 as a part-time community organizer, began as a full-time staffer in 1976 and became its director in 1987. Long was instrumental in many social action campaigns until her retirement in 2006. These included supporting the peaceful desegregation of Cleveland's public schools, keeping the Metro General Hospital a public hospital, promoting community health by assisting with the establishment of the Tremont People's Free Clinic and Neighborhood Family Practice and working to maintain affordable housing in Tremont. She also was a founder of the Women's Center of Greater Cleveland.

Valleyview Homes (Public Housing)

In the Great Depression, affordable housing advocates finally saw the federal government begin to provide low-income housing as part of its New Deal stimulus programs created to revive the economy through construction projects and jobs for unemployed workers. The advocates had argued for public housing to replace the slums. Under the direction of Cleveland City Council member Ernest Bohn, Cleveland became a national leader in this effort with the creation

of a public housing agency in 1933, the Cleveland Metropolitan Housing Authority (CMHA). Despite the opposition of the powerful real estate industry, which strongly objected to government-owned and government-operated housing, Congress passed legislation in 1937 to establish a federal public housing agency. The initial structure of public housing delegated the planning and operation of public housing to local agencies like CMHA, while the federal government provided the financing to construct the housing. Occupancy was limited to low-income residents. Tenants' rents had to pay for the operating costs. This was primarily envisioned to serve as temporary housing for those displaced by the Depression, not as long-term housing.

The Lincoln Heights Civic Association (or Tremont Area Committee) associated with Merrick House proposed a project to CMHA. It was approved, and construction began in May 1939, with occupancy beginning in July 1940. This required the demolition of 264 dwelling units and the relocation of 247 families from the area around St. Theodosius Cathedral. Named Valleyview Homes, the project originally consisted of 582 dwelling units (later reduced to 549) in 72 buildings. Its most notable feature was artwork done through the federally funded Ohio Works Progress Administration Art Project. It included a terra-cotta mural of the project and three other canvas murals, twenty-four ceramic tiles depicting the history of the Tremont neighborhood and eight stone sculpture animals.

The initial Valleyview occupants were all white, conforming to a CMHA policy of racially segregated projects. One household was the Rokakis family. They moved to Tremont in 1955 from Greece. The father came to the United States in 1951 and sent for his family, which included seven children, in 1954. They lived in Valleyview until 1958. Efty Simakis remembered that they were only able to leave and buy a home because an older sister got a job with the Cleveland Trust Company and her savings went toward the down payment. She recalled in a November 4, 2003 Tremont Oral History interview:

[I]*t's hard to remember if there were a lot of people that were in transition, and I think, it was probably a mix. But I do remember, like one family that we were really close to, was an Italian family, definitely, they were not going to get in any better circumstances until the children finished high school and moved out on their own. A lot of families were in that situation, that they were pretty much strapped and were going to stay in that situation until their kids were a little older.*

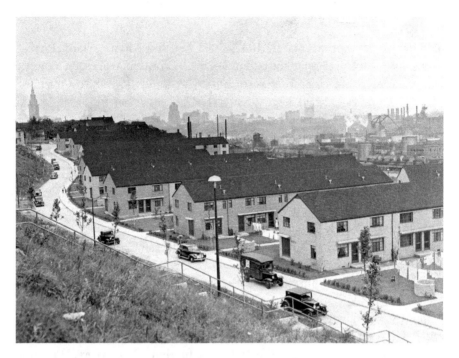

Valleyview public housing project looking toward Public Square, 1940. *Courtesy of Cleveland Memory Project, Michael Schwartz Library, Cleveland State University.*

The best known of her siblings is Jim Rokakis, a graduate of Oberlin College and a lawyer who served on the Cleveland City Council after he was elected in 1978 at the age of twenty-two. He went on in 1997 to become the treasurer of Cuyahoga County, where he led the fight against housing foreclosures and abandonment resulting from the financial crisis of the 2000s. He led the formation of the Cuyahoga County land bank, established in 2009, and then headed the Thriving Communities Institute after his elected position was eliminated in the reform of county government.

Eventually, like many other public housing projects, Valleyview's aging buildings deteriorated. CMHA obtained federal funding for modernization in 1968. However, the year 1969 saw the beginning of the demolition of 206 units. More of its buildings and units were demolished in the 1980s for construction of the Clark Freeway (I-490). Also, the population changed from all or predominantly white to an African American majority. In an October 22, 2003 Tremont Oral History interview, African American Erich Hooper remembered life in Valleyview, to which his family moved from the East Side: "It [was] being changed over from being a poor white facility to

Jim Rokakis/Valleyiew Public Housing. *Courtesy of Jim and Andrew Rokakis.*

now being a poor black facility, which was transferring as the white flight was happening in Tremont." Valleyview's black residents became increasingly isolated from the rest of the Tremont neighborhood. Hooper recalled:

> *We pretty much stayed within the area that we lived in. Having to come outside the projects back then was sometimes difficult. I know that there wasn't really a set curfew in the area, but you knew if you were caught out late at night probably there would be a gang of kids that were going to beat you up. There were a lot of little ethnic gangs if you will and just bad kids—punks that hung out at the park. They called themselves the Lincoln Park Rats.*

Hooper returned to Tremont after college, worked for the city of Cleveland's Recreation Department and in several local restaurants as a cook (and was a

Tremont Pointe (HOPE VI). *Photo by Matthew Ginn (www.MatthewGinn.com).*

cheerleader for the Cleveland Cavaliers and the mascot of the Cleveland Crunch soccer team). Eventually, he and his wife bought a home on West Eleventh Street:

It's a Victorian home. Two levels if you will with an apartment upstairs for the older family, and there was a house behind it that another woman stayed in. So actually, three people could live on this property. There was a lot of that in the old days in Tremont where the family all stayed within one little structure.

Hooper established a farm there, growing organic produce. (He can be viewed talking about his farm in a July 27, 2011 YouTube video.)

CMHA applied to the U.S. Department of Housing and Urban Development (HUD) to demolish Valleyview and rebuild it as a HOPE VI project. In 1995, HUD began a national program to demolish the most "distressed" public housing projects in the country and replace them with mixed-income housing. Because this has led to the loss of many affordable low-income units in the replacement projects, the HOPE VI program became controversial.

In 2004, HUD approved CMHA's application to turn Valleyview into a 190-unit mixed-income project renamed Tremont Pointe. The retention of the Tremont School (again threatened with closure by the CMSD) was critical to CMHA winning this competitive grant in its second submission of a proposal. The residents were relocated in 2004, and a farewell ceremony was held on June 10, 2005, before the demolition of the remaining 243 units began. Three murals done by local painters through the Works Progress Administration's arts program were saved and are now on view at CMHA's headquarters and Cleveland State University. The firm of McCormick, Baron and Salazar, a nationally recognized developer that had managed successful housing projects in Cleveland before, was put in charge of the redevelopment; Cleveland's City Architecture was chosen as the architect.

The resulting project consists of 190 rental units (half of them public housing units) and 24 owner-occupant units, with half being set aside as affordable units for moderate-income owners. Because of the loss of many of the demolished units that were not replaced on a one-for-one basis because of a change in federal housing policy, Merrick House director Gail Long saw this as a turning point in the lack of availability of enough rental units for low-income residents in Tremont. However, in 2015, TWDC in partnership with Ohio City Inc. received a grant from Enterprise Community Partners to explore opportunities for affordable housing in the two neighborhoods.

Ukrainian Museum-Archives

Ukrainian immigrants to Cleveland began arriving in the late nineteenth century. They mainly came from the Lemko, Carpatho-Ruthenia and Galicia regions of eastern Europe. Many were then known as "Ruthenians." They started their first Tremont church in a trolley garage in 1902. In 1910, they built the Sts. Peter and Paul Ukrainian Catholic Church. In the 1930s, the Ukrainian National Home opened in a West Fourteenth Street mansion formerly owned by Thomas Lamson. It closed in 1967. In 1952, displaced Ukrainian scholars founded the Ukrainian Museum-Archives and, in 1977, opened it in a house located at 1202 Kenilworth, which formerly was the home of Ukrainian nuns. Its director, Andrew Fedynski, has been the director since 1987. While he grew up in another Cleveland neighborhood, he came to Tremont to attend services at Sts. Peter and Paul Ukrainian Catholic Church, take Ukrainian language classes at Merrick House and play in Lincoln Park. His family immigrated to the United States in 1948 from an Austrian camp for displaced persons like many other Ukrainians who also arrived in Tremont from postwar Europe's displaced persons camps, according to a June 1990 article from *Northern Ohio LIVE*. The Ukrainian Museum-Archives in Tremont is a repository for a vast amount of materials on Ukraine and Ukrainians beyond just their presence in Tremont.

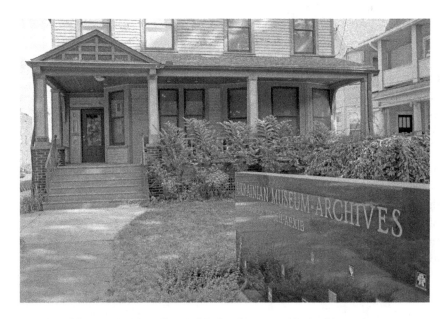

Ukrainian Museum-Archives. *Photo by Matthew Ginn (www.MatthewGinn.com).*

POST–WORLD WAR II DECLINE

Cleveland prospered during World War II as a manufacturing center of war equipment and supplies. After the war ended, the city expected to grow, and its population peaked at 914,000 in 1950. The Tremont neighborhood's population (by the city's definition of its boundaries) was 32,312. Since then, the population of the city and many of its neighborhoods have steadily declined (to a total of 396,000 in the city in 2010). The same has held true in Tremont, which has lost population in every census since then, with the 2010 population at 6,912, a total less than a quarter of its population peak six decades earlier. Like other older, urban neighborhoods with crowded and often substandard housing, many Tremont residents who could afford to leave did. Many joined the postwar exodus to the growing inner-ring suburbs like Parma to the southwest of Cleveland and their newer housing stock. Deindustrialization and the loss of manufacturing jobs in the industrial Flats also contributed to the city's population decline. In addition, the busing order that came after a federal judge ordered the desegregation of Cleveland's public schools in the late 1970s led many whites to leave the city for the suburbs whose mostly white schools were unaffected by this court order, further adding to the city's loss of population.

Highways

The most traumatic losses of population in the Tremont neighborhood came from the building of two interstate highways: I-71/I-90 in the 1960s, which bisected Tremont, and then I-490 in the 1990s, which cut off part of the southern tip of Tremont. This type of destruction and displacement was a phenomenon that affected many poor urban neighborhoods across the United States, along with a similar pattern caused by the urban renewal programs. As part of the interstate federal highway program that began in the 1950s, highway engineers typically designed their path through urban neighborhoods like Tremont, both for efficiency and cost concerns and also because their poor residents lacked the political influence to stop the destruction of part of their neighborhoods. As previously noted, religious leaders in Tremont did persuade the highway engineers to change the designated route in order to save some of Tremont's historic churches. The I-71/I-90 highway into downtown Cleveland, which began construction in the mid-1960s, displaced thousands of Tremont residents with the demolition of their homes, causing a significant decline in its population. The highway opened in 1975. In a February 23, 2003 Tremont Oral History interview, Marie Gubacs, a daughter of Czech immigrants whose father worked in the steel mills and whose mother was a charwoman (janitor) at Tremont School, remembered the highway's devastating impact:

> *The sad part of it, you know, they took some of the homes, they destroyed some of the homes just to make the damn freeway. So people had to move, and the sad part was when they moved, they moved to the suburbs like Parma, Brooklyn. I don't think that many of them stayed put in the neighborhood when they had to sell their houses.*

In the following decade, the Clark Freeway (originally I-290) was built to connect I-90 and I-77 to the east, cutting off part of the southern tip of Tremont from the rest of the neighborhood. Renumbered I-490, it opened in 1990. Originally intended to link to I-271 farther to the east of the city, powerful opposition in the affluent eastern suburb of Shaker Heights to preserve the Shaker Lakes successfully prevented it from extending beyond East Fifty-fifth Street in Slavic Village. In 2015, planning was underway for the "Opportunity Corridor" to extend I-490 in the form of a 3.5-mile boulevard terminating in University

Circle. University Circle is an "eds and meds" district that is home to the Cleveland Clinic and University Hospitals, Case Western Reserve University, and numerous cultural institutions (including the Cleveland Museum of Art and the Cleveland Orchestra).

ARSON

The 1970s saw a continuing decline in the population of Tremont for the reasons cited earlier. The decade also saw yet another, even more alarming reason: arson. The neighborhood's dwindling population was increasingly poorer, making housing owned by absentee landlords less profitable. Some of these speculators decided to recover lost profits by hiring arsonists to burn their buildings down in order to collect on insurance policies on them. Week after week and month after month saw waves of fires in Tremont, to the terror of those residents whose homes were endangered by the fires, as noted in the July 17, 1973 *Plain Dealer* article "Tremont Area Lives in Terror of Fires."

In 1976, an NBC national network broadcast called Tremont the "White South Bronx," an allusion to the fires that swept through that New York City neighborhood when hundreds of apartment buildings had been abandoned and many were burned down by arsonists. One community response was the formation of the Tuesday Night Crime Stoppers by Merrick House to combat arson. Eventually, Joe Nader, the most notorious of the absentee landlords, was found guilty of employing arsonists and imprisoned. This period of arson left the Tremont neighborhood pockmarked with dozens of empty lots where residential buildings previously stood, adding to the already sizable loss of housing due to the construction of I-71/I-90. From 1970 to 1980, the number of housing units in Tremont declined by 30 percent.

This was the decade when the city of Cleveland lost almost a quarter of its population, leaving many thousands of buildings abandoned. In 1976, Cleveland became the second American city (after St. Louis) to establish a land bank. It began to receive empty lots following the demolition of blighted homes left empty and eventually taken by the county for failure to pay property taxes.

TREMONT WEST DEVELOPMENT CORPORATION ORIGIN

It was in this context that the Tremont West Development Corporation (TWDC) was formed in 1979. This organization has since played a key role in the Tremont neighborhood's life. In the 1970s, Shirley Smith, known as the "Godmother of West Virginia," formed and directed the West Side Development Corporation (WSDC) to work with and assist Appalachian migrants who had come to Tremont seeking work. It also helped to develop other organizations, including a credit union, a mental health center, a food co-op and a housing organization. However, Smith became ill and died. Without her leadership, the organization also died. However, Don Pittaway, the director of Merrick House and the secretary of the WSDC, was looking to create a new agency to organize in Tremont. With the agreement of a few members of the WSDC board, its 501(c)3 nonprofit tax-exempt status was used to create the TWDC (with "West" incorporated into the title as part of the agreement).

In 1976, Merrick House hired Larry Bresler (a resident since 1970) and then Chris Warren as his successor as community organizers. A major goal was to organize block clubs and to stop the arson threat. A few hundred residents attended a meeting at the Tremont Free Clinic in the midsummer of 1976 and confronted the city council representative and a Cleveland Police Department representative. This led to a community retreat in September at Merrick House to develop a five-year plan ("Tremont 1981"). That meeting resulted in agreement on several points:

- The creation of a local development corporation;
- Efforts to attract new residents and businesses;
- Using Tremont's assets, like its churches;
- Restoring Lincoln Park as a community asset (given its problems, including drug dealing);
- Coordinating a safety patrol to combat arson.

Bresler left Merrick House soon after this meeting, but Chris Warren was chosen to create what later became TWDC. Warren was profiled in the January 10, 1995 *Cleveland Edition*.

This was the era when community development corporations (CDCs) were emerging in Cleveland neighborhoods where protest organizations had been formed to demand an end to "redlining" by banks, substandard housing and similar issues. The Catholic Diocese of Cleveland and its commission on social justice played a key role in the formation of these organizations by supporting the training and hiring of community organizers. After a demonstration in 1982 against leading business leaders at an event in the exclusive suburban community of Hunting Valley, previous financial support for community organizing by these protest organizations was withdrawn by their major funders. However, these protest organizations spawned offshoot community development corporations devoted to the redevelopment of these same neighborhoods. TWDC would become a leading CDC in Cleveland.

With Warren's efforts, TWDC was formed in 1979 and held its first annual meeting at Merrick House. TWDC is one of the few CDCs in Cleveland with a board elected by its members. Its three initial priorities were the rehabilitation of substandard housing, creation of a tenants' organization (Tremont Neighborhood Tenants) and improvement of the commercial business climate. After the Hough riot in 1966, a nun, Sister Henrietta, and a retired chemist named Bob Wolf formed the Famicos Foundation to rehabilitate substandard housing in that poor African American neighborhood. They developed a model for homeownership for low-income residents in which they would pay rent for the renovated housing and maintain it over time until they could own the home.

Known as the lease-purchase model, it was adopted by the six CDCs, including TWDC, when they formed the Cleveland Housing Network (CHN) in 1981. This affordable housing model and its use in Cleveland neighborhoods gained national recognition. TWDC's first housing effort used this model. Its housing efforts were increased when, in 1980, it had successfully competed for a new (but short-lived) federal program providing

support to local development corporations. With the grant, TWDC could pay Chris Warren as its first full-time director, have its own office (at West Fourteenth and Auburn) and have funding to purchase and rehabilitate homes. Steve Moon, owner of a Tremont grocery store, worked with Bob Wolf of the Famicos Foundation on the housing rehabilitation program.

The TWDC housing rehabilitation program was mentioned at the end of a July 27, 1980 *Plain Dealer* article entitled "Even as Neighborhood Slides, Hope Props It Up": "Always a mixed area, Tremont is now a changing neighborhood. Appalachian whites, blacks and Hispanics, mostly Puerto Ricans, are mixing with the remaining Europeans and Mediterranean ethnics." The reporter painted a dismal picture of Tremont:

> *Mom-and-pop groceries, apartments with clogged plumbing and poor heat in the winter, skinny dogs and fast cats, poverty and toughness, vandalism, burglary and slow to non-existent police response, social workers, priests and preachers make up the neighborhood. Tremont is a poor neighborhood where many of the residents are either on welfare or getting by on poverty-level incomes.*

While the area's city council representative, Lester McFadden, conceded this description, he held out hope for a turnaround that would emulate that of the adjacent Ohio City neighborhood: "I don't know exactly when it's going to start happening, if it hasn't already, and I don't think that it's going to be an overnight thing but it's going to happen."

A companion *Plain Dealer* article entitled "Neighborly Spirit Gone" described the exodus of many of the European immigrants and their children to the suburbs. In answer, Larry Bresler, then vice-president of TWDC, had an op-ed response entitled "Neighborly Spirit Gone? Tremont Talks Back" published in the *Plain Dealer* on August 27, 1980. As the title suggests, Bresler pointed out the positive aspects of a changing Tremont neighborhood, including the work of his fledgling organization.

An example of an extremely dedicated resident contributor to the efforts to improve Tremont was Donna Peters, a longtime resident and mother of nine children. At her death in 2008, she was grandmother to seventeen grandchildren and eleven great-grandchildren. She became an organizer for the Tremont Churches Community Center, was involved in Merrick House's attempt to fight arson and was an original member of the TWDC board, serving until 1995. She worked for the City of Cleveland's health department. Starting in 1989, she coordinated the Tremont Neighborhood

Opportunity Center, providing social services to the poor. Her volunteer activities also included serving as president of the board of Merrick House and on the boards of the Tremont Community Learning Center, the Tremont Organization Against Hunger and the Tremont Free Clinic (in addition to her other civic activities). Confined to a wheelchair due to spinal surgery and arthritis in 1994, she retired in 2003.

It was through the efforts of dedicated individuals like Pittaway, Long, Warren, Bresler, Peters, church leaders and resident members of the TWDC, block clubs and community organizations that the neighborhood began to slowly improve in the 1980s, setting the stage for even greater positive changes in the following decades. Yet Tremont still had to face many challenges along the way. The TWDC, its board and staff would play an important role in this saga. In 1982, its first director, Chris Warren, departed to become director of the Cleveland Housing Network (CHN). He would go on to become a leading figure in the community development movement in Cleveland and become a high-ranking city development official, as well as the head of the Shorebank Cleveland's nonprofit affiliate.

THE ROAD TO RECOVERY

1980s

Scarred by highway destruction, the arson wave and major population losses over the previous few decades, Tremont entered the 1980s with hopes of better days. By 1980, its population had fallen to 10,220, representing a loss of just over 6,000 residents during the 1970s, leaving Tremont with just under one-third of its highest population peak back in 1950. The population loss would continue but slow considerably in the 1980s, with the population only declining by another 1,370 by 1990.

TWDC was not the only organization trying to address the problems of Tremont and serve neighborhood residents. In addition to the churches and Merrick House, other notable organizations included the Tremont Improvement Coalition and the Tremont Neighborhood Opportunity Center.

In addition to drug trafficking in Lincoln Park, during this decade there was considerable youth addiction to glue-sniffing. Tremont kids became the users and distributors of "tulio" or "tuilin," which was found in the supply tanks of the Cuyahoga Chemical Company on West Third Street. A campaign called "SOS (Snuff Out Sniffing)" began to end this. It resulted in state legislation banning this substance in airplane glue and the storage of the chemical.

Progress began to be noticed. In a May 20, 1984 article, *Plain Dealer* architecture critic Wilma Salisbury observed:

Under the leadership of the churches, Merrick House and Tremont West Development Corp., the neighborhood is slowly beginning to revive. The number of vacant houses has been reduced. The arson rate has gone down. Empty lots have been converted into playgrounds, gardens and picnic areas. Neglected old mansions have been purchased and rehabilitated by energetic do-it-yourselfers who appreciate the quality of hardwood floors, stained glass windows, tile fireplaces and brass hardware.

In contrast to its negative 1980 article on Tremont, a February 22, 1987 article in the *Plain Dealer* entitled "A New Surge of Pride on the South Side" was also mostly positive:

Tremont's latest chapter began 10 years ago, when residents dug in their heels and determined to fight the neighborhood's problems together. Just about then, creative newcomers began moving in with their own dreams, and with respect to the old ones…the changes are undeniably there. And so are a growing number of people who want from Tremont what immigrants have always wanted: a home. The first wave in the late 1970s brought artists and urban pioneers. A few had been evicted from rental property elsewhere in the city: in Tremont they could afford to buy. As news spread of cheap housing in an unpretentious area, a second wave brought friends to Tremont, then friends of friends.

Some newcomers were noted in this article. Gary Grabowski grew up in Tremont in a Victorian mansion on Kenilworth Avenue and returned from Detroit with his wife, Rita, to a building on a corner on West Eleventh Street across from Lincoln Park that was owned by an uncle. Eventually, they opened a restaurant called Miracles' while living on the second floor. This could be seen as the beginning of the restaurant revival of Tremont. Chick Holtkamp and his wife, Sharon Box, moved to Tremont from the suburb of Cleveland Heights in 1980 to be closer to his family business, Holtkamp Organ Company. In 1992, his company would restore the organ at Pilgrim Congregational Church (where his father had belonged to the congregation). He invested in property in the neighborhood, most notably Lemko Hall across Kenilworth from Miracles'. In 1931, the immigrant Lemko Association of Cleveland was formed, and its Social & Civic Club was located at 1037 Starkweather. It moved to the current Lemko Hall in 1946. Lemko Hall was built in 1916 and served as a dance hall. It gained film fame as the venue of the wedding party scene in the 1978 movie *The Deer*

Hunter. Holtkamp planned to convert it into condominiums but initially had to rent these units instead. He also had some commercial rental space. One of the commercial tenants in the building for a while was the Right Track recording studio of the Cleveland industrial rock band Nine Inch Nails.

Resident Keith Brown, a graduate of the Levin College of Urban Affairs at Cleveland State University, began to sell Tremont homes to newcomers, overcoming Tremont's past negative image to many outsiders. Brown coined the term "Tremonsters" for neighborhood residents. He formed the Progressive Urban Real Estate (PURE) company in 1986, at first concentrating on sales in Tremont and then expanding to other Cleveland neighborhoods. PURE's Tremont office on Fairfield Avenue was formerly the home of the *Polish Daily News*. He would later be joined by fellow Levin College graduate David Sharkey, who also lived in Tremont and would become a president of the TWDC board. Sharkey succeeded Brown as president of PURE. Sharkey is also a principal of Civic Builders, which has built custom homes at West Eighth Street and Starkweather, called "Tremont Lane." Sharkey noted, "There's a lot of market here, because there's a lot of confidence in Tremont. [I]n Tremont, people are willing to pay a lot of money for rehabbed homes or custom homes." Civic Builders has also constructed two more small housing projects in Tremont called Footbridge Townhouses and Columbus Hill Homes.

Brown denied that he was contributing to the "gentrification" of Tremont. However, there were tensions arising in the neighborhood between those who favored more expensive housing and higher-end retail businesses and those committed to keeping the poorer residents there while improving their lives. One example came in 2002 when Catholic Charities proposed to open a one-hundred-bed homeless women's shelter in a former school building on the grounds of St. Augustine Catholic Church. Hundreds attended a November 19 meeting, with opinions divided over the proposal. Proponents stressed the community's social responsibilities. Opponents warned about the possible negative impacts of a shelter and its occupants on the neighborhood. An outspoken protestor was Nancy Hocepl of the Civilization coffeehouse. Joe Santiago reflected much of the opposition's viewpoint in an October 28, 2003 Cleveland Oral History interview:

> *Right here in this ward, there are over fifty community programs for all kinds of things. The people, a lot of the people here, feel that we have too much already. We have so much on our back, we have so many homeless, we*

have food shelters, we have, you know, so much of that, that a lot of people feel that we can't take no more.

Subsequently, several locations were considered, and the shelter was located downtown instead of in Tremont.

1990s

In 1990, the median household income in Tremont was $11,786, compared to a citywide median household income of $17,822, which showed that the Tremont median household income was only about two-thirds of that of the city of Cleveland. With a subsequent influx of some higher-income households, by 2010 the median household income of Tremont's households had risen compared to the citywide median: $24,175 in Tremont compared to $27,349 citywide, or a ratio of 88 percent. However, the poverty rate remained high over the two decades: 47 percent in 1989, 38 percent in 2000 and also 38 percent again in 2010.

Those concerned about the development of housing possibly pricing poorer Tremont residents out of the neighborhood pointed to the Tremont Ridge townhouse development in what is called lower Tremont (beginning at West Tenth Street). This infill project was begun by Keith Brown and a partner. They hired Keith Sutton and his Sutton Homes homebuilding company to build the houses. After problems arose, TWDC director Emily Lipovan acted as an intermediary. Sutton Homes ended up not only as the contractor but also the owner. When completed, the townhouses sold well but still far above the typical cost of a house in Tremont.

Sutton Homes would go on to build Bergen Village at West Fifth Street and Literary Road, overlooking the Valley below. It was Tremont's first gated community. This luxury housing sold at prices far above typical single-family home prices in Tremont. Sutton Builders' third market-rate housing project was Starkweather Place at Professor and Starkweather (with additional units being built in 2015). As of 2014, Sutton Builders (Sutton Development Group) had built around 250 homes and rehabbed 70 existing buildings in Tremont.

These projects and the conversion of the long-vacant Lincoln Park Baths facing Lincoln Park on Starkweather into luxury condos transformed the Tremont housing market by introducing much higher-priced housing and

Lincoln Park Baths. *Courtesy of Cleveland Memory Project, Michael Schwartz Library, Cleveland State University.*

Tremont Ridge Housing. *Photo by Matthew Ginn (www.MatthewGinn.com).*

higher-income homebuyers. The Lincoln Park bathhouse was the last public bathhouse built by the City of Cleveland. Constructed in 1921, it allowed Tremont residents, especially those employed in the factories in the Flats, who lived without indoor plumbing, to shower. It also served as a recreation center, but eventually the city decided to close it in 1984 because of its declining use and the unacceptably high costs required to modernize it.

Tremont's new housing was encouraged by the City of Cleveland in its efforts to compete with suburban housing. The city adopted a policy in the 1990s of providing fifteen-year, 100 percent property tax abatements for all new housing.

To offset these very expensive housing projects, in addition to its use of the CHN lease-purchase program, TWDC, under the leadership of its executive director, Emily Lipovan, developed a plan for modestly priced housing called the Phoenix Project. TWDC engaged Sutton Homes in partnership with Rysar Properties to build these homes. TWDC acquired the lots, and sixteen homes were built on West Seventh Street in 2001. These homes sold for much lower prices than the Tremont Ridge townhouses built by Sutton Homes.

The July 11, 1997 *Plain Dealer* article "It's a Beautiful Day in the Neighborhood; Ethnic Tremont Now Trend-Mont" described it as "a neighborhood on the cusp." While still labeling Tremont a working-class neighborhood, the writer concluded, "What makes Tremont Tremont, what residents fear will be lost should the area slide into cool-hip status, is its blatant unabashed ethnicity, a sort of big-city, not-too-friendliness, which mixes well with its hints of modernity. The signs, however, are pointing toward continuing gentrification."

ARTISTS AND THE ARTS

A s mentioned in the 1987 *Plain Dealer* article, artists priced out of live/work housing (often illegal) in downtown Cleveland discovered the Tremont neighborhood and its inexpensive (although not always well-maintained) housing. These artists would play an important role in the changes already underway in Tremont. This was not the first time that art played an important role in Tremont. The many churches of Tremont have had religious art as part of their décor. In 1893, Charles Fayette Olney (another Connecticut native) and his wife, Abigail, opened their art gallery on Jennings Avenue. The basis of their gallery was their own private collection. This was Cleveland's first public art gallery. Charles Olney died in 1903 and Abigail in 1904. In 1907, the bulk of their art collection was left to Oberlin College. It became the foundation of the college's Allen Memorial Art Museum's collection.

The Olney Gallery building was sold to the Ukrainian American Center in 1909. Owned by Grace Hospital since 1993, the Olney Gallery has long stood vacant but was being restored in 2015. It is the goal of TWDC that the former gallery can be occupied by a local grocery store. TWDC was awarded a federal grant aimed at planting grocery stores in poor urban areas. City council member Joe Cimperman stated in the October 4, 2015 *Plain Dealer*:

> *Tremont is and always will be a neighborhood of tremendous diversity. With some of the newest market-rate housing and the largest free meal*

Olney Art Gallery. *Photo by Matthew Ginn (www.MatthewGinn.com).*

program in the city at St. Augustine Church, it is a place that embraces everyone…With some of the best restaurants in the city and the farmer's market with the highest use of food stamps, this store is at the intersection of Tremont's need and Tremont's realizing opportunities.

The arts and art programs have played an important role in the revitalization of Tremont over the past quarter century. Arts Renaissance Tremont was founded in 1991, based at Pilgrim Congregational Church. Musical performances are held in the historic church's sanctuary (auditorium).

In 1987, attorney Jean Brandt moved to Tremont from downtown Cleveland, where she had her law office after graduating from the Cleveland-Marshall College of Law at Cleveland State University. Her parents had been born in the Tremont neighborhood. That year, realtor Keith Brown compiled a list of artists who lived and worked in Tremont and tallied forty-one. She opened her law office in Tremont at 1028 Kenilworth in 1990. It became the first storefront renovation project of TWDC. Brandt decided to open an art gallery in her office, with the first exhibit in September 1990, and continued this until she finally closed the gallery twenty-five years later in 2015. She was instrumental in creating the monthly (second Friday night) Tremont ArtWalk, which began on February 12, 1993, with seven businesses

participating. It was modeled on the first Friday art walk in Cleveland's Little Italy neighborhood. Since its inception, it has attracted many visitors to Tremont's art galleries (as well as its bars, restaurants and shops), as the August 12, 2005 *Plain Dealer* noted in "Art Walks Invite Browsers to Take in the Neighborhood." It was preceded by Ron Naso (owner of the Studio Gallery on Professor Avenue) and Robert Ritchie organizing a Halloween art celebration and the opening of the Wildflower exhibit and performance space in Lemko Hall in 1992. Ritchie died in October 2011 and was eulogized on October 21 at a gathering at Lincoln Park by his fellow Tremont artist Tim Herron as a "lovable train wreck."

The Tremont Arts & Cultural Festival began in 1999 and is held annually on a September weekend. It features four categories. These include children's hands-on arts, historical and educational projects; community nonprofit organizations presenting materials about their missions and services; and cultural activities. The last category further includes food sales by churches, nonprofit organizations and restaurants and sales of paintings, sculpture, jewelry, ceramic and photographs created by Tremont and Northeast Ohio artists. The Arts in August program began in 2002. This month-long event features different performing arts events and draws crowds to Lincoln Park and other Tremont venues.

The July 10, 2000 *Plain Dealer* article "Arts and Night Life Booming in Neighborhood of Sharp Contrasts" described the Tremont art scene a decade after Brandt opened her gallery and after the beginning of three of these four major annual arts events:

> *The most interesting thing about Tremont…is the way this once declining Cleveland neighborhood has rebounded by mixing its art and night life. You will find paintings where you would expect to find them…in one of the neighborhood's seven art galleries. But there is just as much art hanging on the walls of Tremont's bars and restaurants. You will find the artists hanging, too—on the streets, in the taverns, plying their trade or talking about it.*

The writer described painter Bridget McGinley, proprietor of Studio 615, the former home of the Northcoast Motorcycle Club. He also described the Literary Café: "The café is small and cozy with paintings decorating the brick walls. It draws a more artsy crowd than your average late-night hangout and lives up to its Bohemian name." Tremont artists Timothy Herron and Brian Pierce came up with the idea of drawing patrons' portraits there.

The participating artists on Friday nights (since 2006) call themselves "The Pretentious Tremont Artists Drawing Club." Also profiled was street artist Scott Radke, who "does sidewalk drawings, murals on garages, and sand sculptures in addition to paintings." He wooed his wife by chalk drawing her on the sidewalk. Music in Edison's Pub, the Lava Lounge and the Hi & Dry In (now the South Side) are mentioned.

One of Tremont's best-known artists is Jeff Chiplis. He arrived in Tremont from Indianapolis in 1980 and met his Cleveland-born wife, Cynthia, when she was working at TWDC as a housing officer. In 1986, he bought some old buildings at the corner of Jefferson and Professor for his studio. Chiplis specializes in sculptures with multicolored neon tubes using recycled materials. In addition to his art work, Chiplis was involved in two notable Tremont events. First, on November 22, 1983, Chiplis (with Chick Holtkamp as his navigator) won the "Free Tremont" race from the isolated neighborhood to downtown Cleveland in a contest to demonstrate the need for the city to reopen closed bridges. Second, on June 11, 2010, after that night's ArtWalk, Chiplis was accosted by two robbers who demanded his cellphone and wallet. When Chiplis refused and fled, he was shot in the back but survived. The Tremont community rallied to his recovery. Chiplis has a studio, home and gardens on several lots at the corner of Professor and Jefferson.

Another artist fixture of Tremont was Dana Depew and his Asterisk Gallery. Growing up on a farm in Medina County, he graduated with an art degree from Kent State University and was introduced to Tremont by his mother, an antiques dealer. He went on the ArtWalk in 2000 like so many other visitors and was inspired to rent a vacant space (once a department store, then a police boxing gym and then an experimental theater) on Professor in 2001, in the same block as Edison's Pub and Fahrenheit restaurant; he opened his Asterisk Gallery there and lived in Tremont. He depended on visitors to the monthly ArtWalk and other Tremont cultural events for many of his customers. Depew operated the gallery until 2010, when escalating rent and too few customers caused its closing. This was lamented by the art community.

His former gallery space is now occupied by a restaurant named the Bourbon Street Barrel Room. Its chef, Johnny Schulze, who is from Baton Rouge, was operating the Zydeco Bistro food truck before he was recruited for this restaurant. "I built a food truck to retire—I didn't want to work for anyone ever again. I tried to say no at first. But Tremont has the right atmosphere; it's culturally diverse and feels like you're outside

the French quarter," he noted, according to the December 20, 2012 *Fresh Water Cleveland* article "Food Truck Chef to Bring Authentic Cajun Fare to Tremont."

However, some artists found homes in Tremont and remain because they own them. One example is ceramic artist Angelica Pozo, profiled in the *Plain Dealer* on September 20, 2015. Born in New York of Cuban and Puerto Rican parents, she arrived in Tremont in 1984. Asked why she picked Tremont as her neighborhood, she replied, "I would not live anywhere else. It's a nice mix, ethnically and financially. I love Tremont's proximity to downtown and the West Side market and any highway."

Asked about her recent work, she said, "I founded an artist-in-residence program under Tremont West Development. We're doing a collaborative ceramic mural in Lincoln Park with Tremont Montessori and church groups. We got an Ohio Arts Council grant."

When visitors to the monthly ArtWalk stroll along Professor, starting at its intersection at West Tenth Street (originally the turnaround space for trolley cars from the viaduct), the sculpture *Dendrite* greets them. This gigantic head sprouting from a canopy of spiky branches is the work of sculptor Olga Ziemska. She said that Tremont's past, including the short-lived Cleveland University, inspired this sculpture.

On the June 2015 ArtWalk, nine art, photography and design venues participated: Banyan Tree, Doubting Thomas Gallery, Housetremont, Lovejoy Photography, Mastroianni Photography and Arts, the Paul Duda Gallery, Robert Hartshorn Studio, Studio Transmutation and the Tremont Arts Committee. More art was on display elsewhere in the neighborhood in places like the Literary Café, Loop coffee shop and Pilgrim Congregational Church.

While the Tremont ArtWalk still draws crowds, some have expressed concern about its arts content. In a July 2013 article in *Cool Cleveland* entitled "Is Tremont Still an Art Community?" artist Josh Usmani reflected on the ArtWalk on its twentieth anniversary. He began with the provocative statement: "Tremont's Art Walk doesn't have much art anymore." Later, he noted, "This article isn't meant to bash Tremont or its inhabitants. On the contrary, the intention is to encourage a public dialogue that results in real solutions to make Tremont a stronger asset to Cleveland's collective arts community."

Usmani quoted perspectives from fourteen Cleveland artists. The first came from Dana Depew: "I love that place. I wouldn't be who I am without my time there. The bottom line is affordability. The model has existed

Dendrite sculpture. *Photo by Nat Neider.*

forever; artists come in when rent is cheap until the place becomes nice and is no longer affordable."

Shawn Mishak claimed, "I began curating in Tremont in 2001…The center of all of this was Asterisk Gallery…Once Asterisk went, which was at the center of the neighborhood, we all knew it was the end of an era." Tim Herron of the Pretentious Tremont Artists similarly said, "The Art Walk was more successful in the beginning because the rent was low and properties were cheaper so artists could afford to move into the area…Now

most of the stops on the Art Walk have little to do with art." James Giar, co-founder of Rust Belt Monster Collective and Drink-in-Draws at Tremont's Lava Lounge, after noting that the owners of restaurants and bars helped artists by displaying their art, stated, "The only problem with restaurants and bars standing in as galleries is that it lacks artist interaction." Joe Ayala commented, "I believe that the changes began with the exit of Dana Depew's Asterisk Gallery and the shooting incident with Jeff Chiplis."

Whatever one's view of the state of art and artists in Tremont, it is indisputable that the arts have been and continue to be a major catalyst in the transformation of the Tremont neighborhood over the past twenty-five years. The monthly ArtWalk and the annual arts programs have brought tens of thousands of residents of the metropolitan region to Tremont, benefitting its art venues and its other businesses, especially its bars and restaurants.

The most recent example of Tremont and the arts was found in the exhibit called Cleveland Neighborhoods at the Harris Stanton Gallery in Cleveland in August and September 2015. It included Tremont homes and buildings drawn by Cleveland artist Tom Roese. His artist's statement notes, "So many images for my drawings are inspired by the industrial history of Cleveland's smoky flats, where steel mills, chemical plants, railroads, and river-traveling ore boats compete for attention. On the bluffs overlooking this laboring soup, the workers' cottages, built by the sweat of early immigrants, are the scenes that command my attention."

BARS AND RESTAURANTS

Tremont always had numerous bars and restaurants, catering almost entirely to the local residents and to workers in the plants in the industrial valley. The more recent proliferation of bars and restaurants appealing also to the rest of the city and region has had a transformative effect on Tremont and its revitalization. The January 18, 2004 *Plain Dealer* article "Tremont Blends Cleveland's Historic with the Hip" reflected this view. After describing Tremont as a "microcosm of the city—yesterday and today" and its "rainbow of ethnicities," the writer then stated, "At night the picture changes. This ethnic stronghold with spectacular views of the downtown skyline is Cleveland's strongest dining, nightlife and gallery district. Chic, cutting-edge restaurants have sprung up on almost every corner, drawing throngs of suburbanites to their nouveau cuisine every weekend."

While Tremont still has some of those mostly local venues frequented primarily by Tremonters, some of its restaurants are regional destinations with award-winning chefs. Many of these Tremont venues have regularly been ranked as among the best in Greater Cleveland in various categories. Some are located in vintage Tremont homes, shops and, in one case (Dante), a former bank. Some have enjoyed long, stable runs (e.g., Sokolowski's), while others have been replaced by similar restaurants. Some of these are profiled here. It should be noted that many longtime residents have complained that they cannot afford to dine at the more expensive newer restaurants. This is one facet of the changes that have occurred in Tremont over the past few decades.

Bars

The efforts of the members of the Woman's Christian Temperance Union (WCTU) and the Anti-Saloon League in the nineteenth century and Prohibition in the early part of the twentieth century failed to change the habits of most immigrants during this era. Tremont's many bars, saloons and social clubs catered to the drinking habits of the resident male laborers. In an April 4, 2003 Tremont Oral History interview, Vic Hanchuk recalled:

> *There were considerable bars in the area, there was a high degree of alcoholism…I mentioned alcoholism and this did bring some problems. One of the problems was that there were bootleggers, of course, the bootleggers were strong during Prohibition because there was nobody that was going to stop people from drinking. They did not care what the Federal Government said. Once Prohibition was over bootleggers did not go completely out of business, they had after hour joints where they would sell alcohol on Sundays. There was a big saying in the neighborhood if you saw a big fancy car it either belongs to a funeral director or to one of the bootleggers or gangsters.*

Today, some of the so-called dive bars remain and are still quite popular. They include the following.

The Hotz Café

It began when John Hotz Sr., a railroad worker, opened a converted storefront in 1919 to serve steelworkers and other laborers. He was a Rusyn who immigrated to the United States in 1905 from the Carpathian Mountains region. Until the 1940s, the Hotz Café didn't serve women. The April 10, 2015 *Plain Dealer* article "No Pretending and No Pretense at 97-Year Old Joint" described it thusly:

> *The shot-and-a-beer joint—2529 West 10th Street—has been open for 97 years. It's a family institution spanning generations, not to mention a pillar of saloon stabilization in the ever-changing Tremont neighborhood. Hotz boasts a look and feel that has changed little in that time. The mahogany bar and the bottle-cap bar stools are straight out of 1919. The shuffleboard game is a more recent addition, from 1936.*

Hotz's grandson John Hotz, the current owner since 1991, "sees himself as caretaker of a family and neighborhood tradition." (For a view inside the Hotz Café, see a July 15, 2013 YouTube video.)

Pat's in the Flats

This bar was opened by the Hanych family in 1945. A May 15, 2015 *Plain Dealer* article described it: "Pat's in the Flats has provided a bastion of saloon stability in Cleveland's Tremont neighborhood even as Tremont has changed. Located at 2233 West Third Street, it sits along an artery for trucks and tankers. It's also in a no man's land—at the bottom of the hill, between Tremont and the industrial Flats."

The article described the seventy-fifth birthday of owner and bartender Pat Hanych, a Ukrainian American who started working there at age eleven. She refused to sell even after robbers killed her brother in the bar in 1969 and her father died a few months later. She said, "Tremont has really changed—it went from a workingman, blue-collar neighborhood to a lot more of these Yuppies."

The Rowley Inn

For around sixty years, this bar, located near the *Christmas Story* House, has served the same kind of customers as the previous two. According to an August 20–26, 2014 article in *SCENE Magazine*, a new owner didn't plan to make major changes: "I'm not looking to change a whole lot. I don't want to mess with that cool, old, corner-dive-bar-that's-been-there-for-60-years-vibe." It does have a Trivia Night.

Prosperity Social Club

An example of a makeover of an old Tremont tavern is the Prosperity Social Club. Founded in 1938 as Dempsey's Oasis Night Club, it is located at 1109 Starkweather across from Lincoln Park and next to the Lincoln Park bathhouse condos and a now vacant building that once housed the small Royal movie theater, one of several theaters in and near the Tremont neighborhood. Polish immigrant Stanley Dembowski, the original owner of the bar, lost his bet on boxer Jack Dempsey, who lost the heavyweight boxing

crown to Gene Tunney in 1926. Dembowski said that he was subsequently dubbed "Dempsey" and decided to name the bar that also. He said that he added "Oasis" because "that's where thirsty people go to get dethirsted." Dembowski had ten children and at age eighty-six was the grandfather of twenty-two, great-grandfather of twenty-four and great-great-grandfather of ten, as the *Plain Dealer* reported on February 11, 1982.

In 2005, then Tremont resident Bonnie Flinner purchased the bar. Flinner's family owned the Bit of Budapest restaurant in Parma Heights (home to many former Tremont residents). After waitressing there, she went to the Irish pub Nighttown in Cleveland Heights, where she worked for twelve years. Instead of a bar, she decided to turn Dempsey's Oasis into a supper club and renamed it as a tongue-in-cheek salute to its Depression-era origin.

These examples complement more modernized bars, each with its own distinctive history and clientele. On Professor Street, longtime Tremont resident and real estate investor Tom Leneghan and his brother, Pete, opened the Tree House in 1996. Once a meat market, the building's price was cheap, although its condition was not good. One of six children of Irish immigrants, Tom Leneghan grew up working in his father's Pride of Erin bar on Lorain Avenue. The iron tree sculpture inside the bar was done by Joe Scully (the owner of the Union Gospel Press building for a while). A mural adorns the exterior wall of the Treehouse facing a large patio. Tom's brother, Pete, became co-owner of P.J. McIntyre's Irish pub in Cleveland's Kamm Corner neighborhood and also became the co-owner of the Stone Mad Irish pub near Gordon Square in the Detroit Shoreway neighborhood.

Mark LaGrange bought Edison's Pub, named after Thomas Edison, in 1989 and also purchased other Tremont properties. In an October 30, 2003 Tremont Oral History interview, Mollie Alstott remembered growing up on Professor Street in Tremont:

> [O]ur house is still standing today, in fact its Edison's Pub. It's one of the popular places where people play darts I guess. I guess, it's a bar, it's quite popular with the younger crowd. My Dad [an immigrant from Austria-Hungary] had a confectionary store up front and we lived in quarters behind it, so we had two bedrooms, a bathroom, a living room, and kitchen. We did have a back porch and it overlooked the back yard and we even had flowers in the back and a garage. And upstairs, up front was a

Tree House mural. *Photo by Nat Neider.*

dentist office and he was good for the neighborhood. Doctor Stouffer, I think that he was Hungarian. And then there were quarters for another family behind him.

Some other popular bars in Tremont have included the Lava Lounge, the Flying Monkey Pub, the South Side, the Tremont Tap House, the Clark Bar, the Duck Island Club and the Velvet Tango Room.

RESTAURANTS

The restaurant scene in Tremont took off beginning with a few restaurants in the late 1980s. Then in the 1990s and beyond, more joined the original ones. As more opened, a few have become regional destination restaurants with widely recognized chefs (Michael Symon being the most famous). This proliferation of restaurants both contributed to the rise of Cleveland as an excellent culinary city and also gave visitors another reason to frequent the Tremont neighborhood. Some have come and gone, while others have had staying power. Following are profiles of just a few of these many restaurants.

Miracles'

The arrival of the Grabowskis and their 1986 opening of Miracles' in a house at the corner of West Eleventh Street and Kenilworth facing Lincoln Park would usher in the rise of Tremont as a culinary destination. It was probably best known for its potato pancakes (inspired by a recipe from Gary's family). Its name came from what Father McNulty called the couple when he married them at St. Augustine Church. It expanded with the Grabowskis' purchase of a Ukrainian shop next door. Miracles' closed in 1994 but reopened in 1996. It closed again in 2000 for personal reasons, as noted by the August 12, 2005 *Plain Dealer* article "Restaurants and Galleries Set Up Shop in Storefronts." Subsequently, Miracles' was followed by a succession of restaurants, including the Sage Bistro, which in turn was followed by the Bistro on Lincoln Park. The most recent occupant was Ligali's Bistro, which closed in June 2015. The building has been purchased by yet another restaurateur.

Lola Bistro/Lolita

In March 1997, a restaurant opened in Tremont at the corner of Professor and Literary that would have an even greater influence on Tremont's

culinary reputation. Lola, named after his aunt, was the creation of Chef Michael Symon and his wife (then his fiancée), Liz Shanahan, the general manager. They bought the building, which had housed the restaurant Bohemia, another pioneering Tremont restaurant, and before that the Golden Spot diner.

Symon was born in Cleveland of Greek and Sicilian heritage. Starting his cooking career in a local Italian restaurant, Symon graduated from the Culinary Institute of America in 1990. He then worked in three local restaurants and was a resident of the Tremont neighborhood. According to Michael Ruhlman's biography of Symon, *The Soul of a Chef: The Journey Toward Perfection*: "Lola opened in March 1997. But not quietly. Despite the fact that Michael and Liz had not sent out announcements or even mentioned an official opening, Lola was jammed that first night. It seemed as if the entire city had been waiting to see what Michael Symon would create."

The following year, Symon was named a Best New Chef by *Food & Wine* magazine. In its October 2000 issue, *Gourmet* magazine named Lola one of America's best restaurants. With these honors, Symon had a meteoric rise. Ruhlman described Lola's operation in detail: "Lola was a friendly place. And it was distinctly American. Michael Symon was a distinctly American chef, unencumbered by the legacy of classical cuisine,

Michael Symon, chef/owner of Lola (now Lolita). *Courtesy of Michael Symon.*

mentored by no chef after he left cooking school, and serving the kind of food Americans like to eat."

In 2005, Symon converted Lola into Lolita, reopening Lola a year later on East Fourth Street in downtown Cleveland. On July 19, 2009, during the Taste of Tremont event, "Michael Symon Corner" was dedicated in front of Lolita at the corner of Professor and Literary (a video of the event can be viewed on YouTube). Symon went on to greater fame as an Iron Chef on the Food Network and then on several of the Food Network's cooking shows, as well as *The Chew* on the ABC-TV Network. Symon has opened additional restaurants in the Cleveland region and in Detroit, Indianapolis, New York, Pittsburgh and Austin, Texas. He has published cookbooks and won many prestigious awards for his cooking. With his mounting fame, Symon said in 2015:

> *Out of everything that we have been fortunate enough to accomplish in our 17 years of business what I am most proud of is the effect we have had on the Tremont neighborhood...As the chefs and restaurants came so did the great shops and more art galleries & now we have what is still Cleveland's greatest urban neighborhood filled with many of its best chefs.*

Fat Cats

Ricardo Sandoval was born in Rocky River, one of eight children that are half Irish and half Filipino. He opened his first restaurant in Broadview Heights in 1989. In 1997, soon after the Lola Bistro opened, he (and a partner) bought a century-old house on the bluff overlooking the industrial valley at 2061 West Tenth Street containing a restaurant named the Heart of the Southside and transformed it into Fat Cats. In the August 7, 2015 *Cleveland SCENE*, Sandoval explained, "I definitely wanted to be part of the renaissance of Tremont. The balance of people in various socioeconomic backgrounds, artists, young professionals, generations of families, proximity to downtown and history. It's the crown-jewel neighborhood of Cleveland."

Sandoval was an early Cleveland proponent of the farm-to-table movement. The restaurant has its own herb and vegetable gardens. Sandoval later opened the Lava Lounge in Tremont (and the Felice Urban Café in an old house in Cleveland's East Side Larchmere neighborhood).

Fahrenheit

Another notable restaurant opened in September 2002 when Tremont resident Rocco Whalen (at the age of twenty-four) opened Fahrenheit at 2417 Professor (a few blocks from Lola and across the street from the office of TWDC). Whalen had previously worked in Wolfgang Puck's West Coast restaurants. When he returned to Cleveland in 2001, he was the executive chef of a leading restaurant in the downtown Warehouse District. As a candidate for the TWDC board, Whalen stated, "I chose to open a business in Tremont because this community is diverse, artistic, gentrified, and generally wonderful. I feel as though Clevelanders can come to Tremont and be enveloped by some of the best dining in the city. I chose to reside in Tremont for the same reasons of artistic attitudes, diversity and gentrification."

Whalen bought a home on Starkweather. He became nationally known for his 2012 appearance on the TV show *Fat Chef* when he lost 85 of his 407 pounds. He now owns several food outlets in Cleveland in addition to Fahrenheit.

Grumpy's

Grumpy's Café and Bakery was originally located on Literary and Thurman. Its name came from the demeanor of its owner after he fell into the basement while renovating the building. In 2002, Kathy Owad, who was a server there, bought the business and dropped the bakery. She lived in suburban Bay Village, and a sister lived in Tremont. In 2004, Grumpy's was destroyed in a fire. Despite this setback and with community support, Owad decided to move the restaurant to its present location at 2621 West Fourteenth Street. She first rented space in the closed Gatherings hair salon owned by the adjacent St. George Antiochian Orthodox Church, a Syrian Christian group, which purchased its building in 1933 from the Lincoln Park Methodist Episcopal Church. Then, after renovations, it also suffered a devastating fire but was rebuilt and reopened in 1935. Owad reopened Grumpy's in January 2007. A restaurant review later that year in *SCENE Magazine* described Grumpy's:

> From the outside, the handsome building (complete with its own enclosed parking lot and a small patio destined for outdoor dining) is reminiscent of an old southwestern saloon, complete with bay windows and burgundy

awnings. Inside, though, the space is entirely up-to-date—done in brilliant shades of sunflower, sage, tomato, and violet, and set off with gleaming white woodwork, soaring ceilings, and gallery-style lighting. In fact, the rear dining room actually is a gallery of sorts.

Lucky's

Located at 777 Starkweather (the numerical address explains its name), Lucky's Café, formerly Tymoe's bar, is another popular Tremont dining venue, especially for weekend brunches. It opened in 2002. The mural on its exterior wall was done by Tremont artist Scott Radke. Its owner and chef is Heather Haviland. (A lengthy interview with Haviland can be viewed on YouTube.)

Civilization

In 1990, Nancy and Bob Hocepl opened the Civilization coffee shop (originally called Cravings) in the space at Kenilworth and West Eleventh Street at a corner of Lincoln Park across from Lemko Hall. It was formerly a pharmacy and then home to a commercial printer. Nancy was a nurse and Bob a commercial photographer living in the western suburb of Lakewood before moving to Tremont. Bob's grandparents had settled in Tremont, and he was born there. The couple bought the dilapidated storefront with their earnings from selling their renovated Tremont home. Civilization was a featured coffeehouse in sociologist Ray Oldenburg's 2001 book *Celebrating Third Places: Inspiring Stories About the Great Good Places at the Heart of Our Communities* (after the two places of home and the workplace). Bob Hocepl's chapter describes the couple's slow start on a financial shoestring:

> *We had no money in the bank, and the concept of a specialty food store and coffee bar in a poor inner-city neighborhood was not something that inspired confidence in many suppliers. Thankfully, we began to build a small but loyal following—just a trickle at first, but with some good press we soon became a destination for folks from throughout the region looking for specialty coffee, espresso drinks, teas, and chocolates. We also began to establish ourselves as a crossroads for the neighborhood, unwittingly creating what Dr. Oldenburg describes as a "third place."*

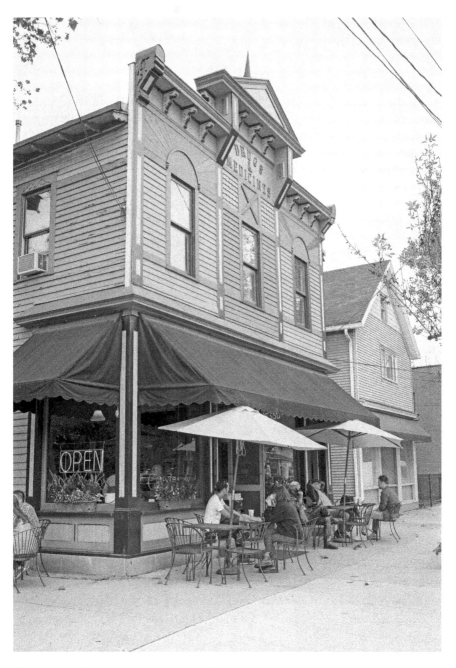

Civilization coffee shop. *Photo by Matthew Ginn (www.MatthewGinn.com).*

Having discovered Oldenburg's previous book, entitled *The Great Good Place*, Hocepl wrote:

> *After quickly reading the book, I realized that there was a name for the type of establishment we were building, and I was bolstered by the knowledge I was on the same philosophical track that others had been on for some time. Now we had an even greater mission in addition to restoring a building, creating a business, and helping to revitalize a neighborhood—we were taking part in the resurrection of a form of social interaction that was almost extinct in America.*

Hocepl then described a day in the life of Civilization, from opening to closing and the clientele. He ended with hundreds attending a tenth-anniversary celebration (a video of the event can be viewed on YouTube). Civilization could be said to be the forerunner of the later "gentrification" of some of the commercial aspects of Tremont—in contrast, for example, to the working-class dive bars or Sokolowki's. It first had to overcome the negative image of Lincoln Park across the street. One way to improve its image as a safe destination and hangout was to provide free coffee to Cleveland police officers.

Sokolowski's University Inn

Long before any of these restaurants and others that have since disappeared over more than a quarter century, there has been Sokolowski's University Inn, operated by a Polish family since 1923. Originally a bar, it became a restaurant during the building of the Innerbelt, serving food cafeteria style. Its history and a view of changes in Tremont are included in an October 15, 2003 Tremont Oral History interview with Bernie Sokolowski. When completed, the Towpath Trail will run right by this restaurant, which is located at the edge of the bluff overlooking the industrial valley. In a June 10, 2010 video of the Food Network's *Best Thing I Ever Ate* TV show, Michael Symon appears with Michael Sokolowski singing the praises of its pierogis. Mike and Bernie Sokolowski grew up above the restaurant. Bernie said, "I feel my dad everywhere in this place. I can feel his spirit here. This will sound corny, but at 10 to 11 every morning we ring a bell and gather in front of a painting of the black Madonna in the kitchen. It's a Polish custom. We owe a lot to Polish pride and prayer."

This is only a sampling of Tremont's many restaurants, offering a wide choice from upscale destinations to neighborhood cafés and coffeehouses. Parallax, one of several Cleveland restaurants owned by Zack Bruell, is included in his annual "Tour de Bruell." Along with the arts-related businesses, programs and festivals, the many restaurants, bars and coffee shops have become the other main attraction for visitors to this neighborhood. However, this was not necessarily seen as a positive development by older residents. In an October 26, 2003 Tremont Oral History interview, Frank Boulton, who worked for the City of Cleveland's water department, reflected this viewpoint:

> *Well, the restaurants going in and everything is probably helping the neighborhood to get a nicer reputation but it doesn't do anything for the people of the area that can't afford to go to them. You've got to understand that that's not a very high-income area to most of the people that live there so therefore they can't frequent these restaurants. Most of this new building and construction going on in the area is aimed at young people with high profile jobs downtown, working downtown, making it convenient for them to live in the area close to getting to downtown. It isn't for the people that live in the area. Those restaurants and buildings aren't being put up for them.*

TREMONT WEST DEVELOPMENT CORPORATION CONTEMPORARY PROFILE

The mission of Tremont West Development Corporation reads, "We serve Tremont by organizing an inclusive community, building a unified neighborhood, and promoting a national destination."

The staff reports to an elected fifteen-member board of directors. In 2015, the staff of ten was headed by Executive Director Cory Riordan. Staffers had the

TWDC staff, 2015. *Courtesy of Tremont West Development Corporation (TWDC).*

following assignments: assistant director, office manager, physical development director, community involvement manager, property manager/safety coordinator, Ward 3 area coordinator, community organizer/program manager and Tremont Farmers' Market manager. There was also an AmeriCorps VISTA member. Standing committees include Executive, Economic Development, Safety and (Ad Hoc) Arts. TWDC publishes a monthly newspaper called *Inside Tremont*. In 2012–14, TWDC's budgets averaged about $900,000.

ANNUAL MEETINGS

Unlike most other Cleveland CDCs, TWDC has resident members. At its annual meeting, the members vote to elect the board of directors. These are often contested elections. At its May 28, 2015 annual meeting, held at the Annunciation Greek Orthodox Church, the 130 members in attendance voted for 10 candidates vying for seven of fifteen seats. Of the 7 elected, 3 were incumbent board directors. Board president Lynn McLaughlin Murray was reelected.

Of the major accomplishments cited in the TWDC 2014–2015 Annual Report, the plans for Duck Island and Clark Avenue and the proposed Scranton Southside Historic District stood out. In process was planning for the Tremont Montessori School and the Towpath Trail. Initiatives included the Healthy Corner Store Initiative, the West Side Bike Share partnership, the Storefront Incubator Program (assisting start-up businesses) and the *Christmas Story* House Neighborhood Restoration Program. Various events were mentioned in the report, including the 2014 Taste of Tremont, which brought fifty thousand visitors to the neighborhood. Among the development projects cited were the Fairmont Creamery and Our Lady of Mercy (a vacant Slovak church facing Lincoln Park that has been converted into offices), both adaptive reuse projects. TWDC's commitment to affordable housing and income diversity was reiterated.

PLANNING

TWDC plays a key role in planning for Tremont, both the overall neighborhood and also for sub-areas. Its planning results have been endorsed by the Cleveland City Planning Commission. Following are five examples

of planning that involved TWDC. Its executive director, Cory Riordan, is a graduate of the Cleveland State University's Levin College of Urban Affair's graduate program in urban planning.

2007 Strategic Investment Initiative

Shortly before the national economic crisis that emerged in 2008, Cleveland's Neighborhood Progress Inc. (NPI), now Cleveland Neighborhood Progress, which supports CDCs, launched a Strategic Investment Initiative (SII) with support from Cleveland foundations and Enterprise Community Partners. It was aimed at comprehensive neighborhood redevelopment in selected target areas in six neighborhoods by six selected CDCs. Tremont and TWDC were among those selected by NPI. In this competitive process, key selection factors included areas with stable or rising real estate values and assets such as parks and cultural institutions. Each CDC was to feature a large-scale anchor project and then develop "model blocks" around it.

After choosing a Steering Committee and conducting community meetings with residents, TWDC decided to focus on five Tremont sub-neighborhoods: North Tremont, South Tremont, Duck Island, Lincoln Heights and SoTre.

One of the overall objectives was to "establish Tremont's different districts as neighborhoods of choice to live in through real estate development promoting their strengths." While different objectives were identified for each of these five districts, TWDC also had overall goals for the entire neighborhood:

- Transportation and infrastructure enhancements providing neighborhood identity;
- Enhancements to the West Fourteenth Street bridge;
- Encouraging interaction between block clubs and neighborhood districts to connect and unify the community;
- Create a series of walking, biking and driving routes that connect the neighborhood;
- Create parks and community gardens to promote places where a "melting pot" of cultures can exist;
- Retain the existing housing alternatives that are affordable for all Tremont residents.

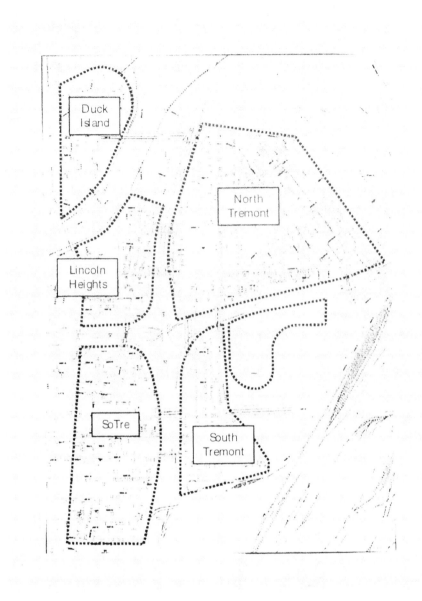

Tremont sub-neighborhoods. *Courtesy of Tremont West Development Corporation (TWDC).*

For its target area for model blocks, TWDC chose the blocks immediately adjacent to two new housing projects: Tremont Pointe and the Starkweather Homes projects. A work plan was completed in April 2007 to implement this plan.

2013–16 Strategic Plan

In May 2013, TWDC adopted a three-year strategic plan with the assistance of Strategy Design Partners. The Vision Statement read, "Tremont is the ideal urban village, led by a growing population of dedicated people, filled with desirable amenities and essential services, and welcoming to all." Some of the major goals of this plan were:

- Improve the block club system;
- Improve safety;
- Create mini-master plans for neighborhood districts;
- Lead development of the West Twenty-fifth Street, Duck Island, MetroHealth and Clark Field corridors;
- Develop an investment strategy for mixed-income/affordable housing;
- Create, promote and drive investment in the Scranton Historic District;
- Increase and diversify membership.

Numerous strategies were identified to achieve these goals.

2014 Duck Island Plan

Duck Island is a small part of the Tremont neighborhood centered on the Abbey Avenue Bridge between Tremont and Ohio City. It is bounded by Lorain Avenue to the north (and the Lorain-Carnegie/Hope Memorial Bridge), Train Avenue and Scranton Road to the south and east and West Twenty-fifth Street to the west. Its western border is a short distance from the city's West Side Market, an RTA light rail station and the bustling West Twenty-fifth Street scene in Ohio City. Unrelated to ducks, it supposedly got its name from those running ("ducking") from the police through the area during Prohibition.

With the rise of Tremont over the past years in new development, businesses and residents, and though Duck Island is not an island, it remained rather secluded; its residents have enjoyed this relative isolation. That has now begun to change. Several developers have plans to build housing in Duck Island. The largest will be Andrew Brickman's project north of the

Hops (West Fourteenth and Mentor-North). *Photo by Matthew Ginn (www.MatthewGinn.com).*

Lorain-Carnegie bridge. Another interested developer is Sam McNulty, the owner of popular restaurants and bars just a few blocks away on West Twenty-fifth Street. Matt Berges, a Duck Island resident, is developing single-family homes through his Duck Island Collaborative, which includes several partners.

A Forest City Brewery is planned for Columbus Road. The master brewer will be Corey Miller, who is associated with Paul Benner's Cleveland Brew Shop, which was first located in Tremont to cater to home beer brewers. It is now located on Lorain Avenue in Ohio City. Miller is growing hops for both home brewers and commercial brewers in Tremont along West Fourteenth Street.

In 2013, TWDC, with funding from Neighborhood Progress Inc., hired Kent State University's Cleveland Urban Design Collaborative to conduct a planning charrette with Duck Island residents and businesses. It was held in December 2013 at St. Wendelin Church. Out of that process came a TWDC development plan for Duck Island. Among its main features are:

- An appropriate scale of development, with denser projects being located on the main streets;
- The enhancement of Abbey Park;

- Maintenance of public access to the bluffs and protection of views of the Industrial Valley and downtown Cleveland;
- Creation of a new streetscape along Abbey Avenue as a gateway to the neighborhood;
- Creation of walking trails and open space.

Clark Avenue Corridor

Clark Avenue is an important transit route running through the Tremont neighborhood and, to the west, the Clark-Fulton and Stockyards neighborhoods. With the aim of revitalizing this corridor, the City of Cleveland and TWDC obtained funding from the Northeast Ohio Areawide Coordinating Agency (NOACA) through the federal Transportation for Livable Communities program. A Clark Avenue Corridor Plan, prepared by consultants Behnke Landscape Architecture and Michael Baker, was released in April 2015. It built on the TWDC Strategic Plan prepared in 2013. A Community Advisory Committee was formed, and the consultants held three public meetings. The plan contains numerous recommendations. Among those were to make Clark Avenue a "complete street" with enhanced access for pedestrians and bicyclists, improved streetscape and traffic calming. In the Tremont section (identity zone), Clark Avenue will intersect with the future extension of the Towpath Trail.

Tremont Montessori Elementary School Strategic Plan

As previously noted, the Tremont Montessori Elementary School is an important institutional asset for Tremont. It has survived previous threats to close it. The Friends of Tremont Montessori was formed to protect and support the school. It is now the subject of a CMSD facilities planning process for the renovation and replacement of many of its school buildings. The district has seen declining enrollment for a long time even as it undertook to renovate and replace many of its aging buildings through bond funding and a partnership with the state's school facilities agency. TWDC and the Friends of Tremont Montessori partnered to form a Strategic Planning

Committee to work with the CMSD to determine the future of the school and its building. In a May 18, 2015 draft report prepared by the Architectural Vision Group, it was estimated that to demolish the current building and replace it with a new and smaller building would cost more than $17 million, with CMSD's share being about $5.5 million (and the State of Ohio paying the rest of the cost).

The alternative is to renovate the building (and add a kitchen/cafeteria) at an estimated cost of more than $21 million, with CMSD's share being almost $17 million. A third option is for the CMSD to remodel the building at a cost of $5 million without any state construction matching funding. In order to qualify for state funding for the estimated renovation costs, the student enrollment would have to be at full capacity (with 575 enrolled in 2015). There is considerable sentiment among Tremont residents (regardless of whether they have children attending the school) to preserve and modernize the existing historic building rather than seeing it demolished and replaced.

SPECIAL PROJECTS

Storefront Incubator

In 2012, TWDC launched a program to help pop-up stores in a space in the front of TWDC's office at 2406 Professor Avenue. The aim is to promote new businesses in Tremont. A decade earlier, TWDC had sponsored a business incubator.

Healthy Corner Store Initiative

Recently, there has been both national and local attention paid to so-called food deserts. The City of Cleveland, the County of Cuyahoga and some Cleveland CDCs have developed fresh food initiatives to address the lack of these choices in poor neighborhoods. Despite Tremont's many trendy but expensive restaurants, for the neighborhood's poorer residents there haven't been fresh and healthier foods generally available at local food stores. In 2012, TWDC initiated planning for a pilot program to address this issue. Lindsay Smetana, a VISTA Americorps volunteer, was assigned to research responses. This led to an approach to local convenience stores about

participating in a pilot program. Initially, three stores agreed to participate, with two more added in 2015. TWDC provided each of these stores with a cooler to be stocked with fresh produce. Funding came from the Cleveland Foundation and Enterprise Community Partners. The stores have notices posted to inform customers about this program.

Bike-Share

In 2014, TWDC in partnership with community development corporations in the Ohio City and Detroit Shoreway neighborhoods won a $10,000 award from Enterprise Community Partners' second annual Nurture an Idea Award CrowdRise Challenge. This allowed TWDC to establish a bike-share station in front of the Civilization coffee shop. The bike rentals are operated by Zagster, a private firm. As of July 2015, the Tremont station is one of thirteen in the city. The Northeast Ohio Areawide Coordinating Agency approved a grant in June 2015 to build a citywide bike-share system. This has been advocated by Bike Cleveland as part of its goal of making Cleveland more bike-friendly.

Block Clubs

Neighborhood organizing in Cleveland became a hallmark of the reaction to the city's decline in the 1970s. As previously mentioned, protest organizations formed in several neighborhoods. With their demise and the rise of the CDCs such as TWDC, confrontational community organizing ended with the withdrawal of financial support for these protest organizations. However, CDCs gradually resumed community organizing with a basis being the formation of resident block clubs. These serve as the eyes and ears of Cleveland's neighborhoods, informing the CDCs and their city council members of problems. They also contribute to neighborhood safety and improvement projects and develop resident leadership.

In Tremont, TWDC and its staff work with ten block clubs. They represent the following sub-areas of the neighborhood: Auburn–Lincoln Park; Central Tremont; Clark Scranton; Duck Island; Holmden-Buhrer-Rowley; Lincoln Heights; Mentor-Castle-Clark; Metro-North; North of Literary; and South of Jefferson. They meet most months, and their

activities are reported in the "Block Club Happenings" section of the monthly newspaper of TWDC called *Inside Tremont*. Their officers and many of their members attend the annual TWDC meetings.

In an October 30, 2003 Tremont Oral History interview, then Tremont Scoops owner Marianne Ludwig described the types of issues addressed by her block club, North of Literary:

> *Supposedly, whenever there's a new business coming into the area the Block Club is supposed to be consulted. A lot of times people that have particular issues with a property that's not being kept up, you know, the block club will be asked for support from the adjacent property owners. We've gone to City Council meetings in support of having a property condemned and things like that. We have a little park that we built and are forced to maintain because the city of Cleveland does not accept its responsibility to take care of its property...We also, you know, try to keep each other informed about problems with crime. Citizen initiatives, it's also an opportunity to get together with your neighbors once a month and keep up to date on what's going on. We have a core group of maybe ten to fifteen people that are pretty active every single month and maybe another group of ten to fifteen people that just kind of show up when they get a burr under their saddle or something...Tremont definitely is a group of people that likes to chime in on what's bugging them.*

TREMONT GARDENERS

In 2005, a group of residents formed Tremont Gardeners. Beginning with a beautification project, they started with a flower sale to raise funds for a plantings project in Lincoln Park. They were assisted by TWDC and a staffer from the Cleveland Botanical Garden's Learning Garden. They were later joined by a group calling itself the "Brevier Posse" to create and maintain gateway gardens at the entrances to Lincoln Park. Volunteers led

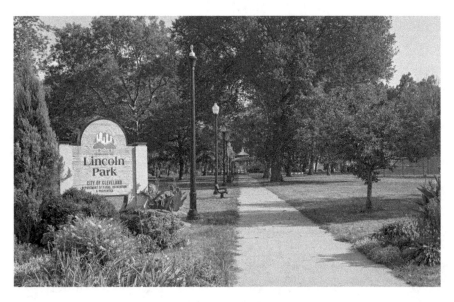

Lincoln Park. *Photo by Matthew Ginn (www.MatthewGinn.com).*

by the Hocepls had returned and repaired the gazebo that sits in the center of the park.

Another project was the Scranton Road Beautification Project, which created plantings in pocket gardens along Scranton Road (initially funded through a Neighborhood Connections grant). Members also have done corner plantings in other locations in Tremont and at the I-90 exit to West Twenty-fifth Street. They have an annual flower sale fundraiser in May.

In 2015, Merrick House inaugurated a Learning Garden, planned and developed by participants in its Summer Youth Employment program. It was supported by the Ohio State University Extension Summer Sprout program and funding from the Thomas White Foundation, Tremont Trek and private donors.

Cleveland is known as a leader in urban agriculture, with community gardens and several farms throughout its neighborhoods. It legalized urban agriculture through zoning in 2007. An annual Cleveland Garden Walk showcases gardens in selected Cleveland neighborhoods. Gardens in Tremont were featured in 2014. This included a bioswale at the Paul Duda Gallery and Robert Hartshorn Studio. It is part of the Professor Avenue Streetscape Project.

FILMS

Tremont became more widely known because it was a location for the filming of two movies. The first was *The Deer Hunter*, released in 1978. It is a war saga about steelworkers from western Pennsylvania who survive captivity in the Vietnam War. Its scenes of Viet Cong–mandated Russian roulette by the prisoners were very controversial. Directed by Michael Cimino, the cast included Robert De Niro, Meryl Streep, Christopher Walken and John Cazale. *The Deer Hunter* won five Academy Awards in 1979, including Best Picture, Best Director and Best Supporting Actor for Walken. The movie was variously filmed in eight different U.S. locales in Pennsylvania, West Virginia, Washington state and Cleveland. Two major prewar scenes were filmed in Tremont, as the article "When De Niro and Streep Walked Tremont's Streets" noted in the August 12, 2005 *Plain Dealer*. The wedding scene was filmed in the St. Theodosius Russian Orthodox Cathedral. The wedding reception scene was filmed in Lemko Hall. Volunteer Tremont residents participated as extras in these two scenes.

The second film was 1983's *A Christmas Story*. The film is about little Ralphie Parker's dream of getting a Red Ryder rifle for Christmas. The director, Bob Clark, was attracted to Cleveland because of the availability of the downtown Higbee department store and a house in the Tremont neighborhood that appeared in the movie *The Deer Hunter*. The house is at the corner of West Eleventh Street and Rowley Avenue. Some scenes were filmed at the "Parker" house, and others were later filmed in Ontario, Canada. The restored house was bought in 2005 on eBay by Brian Jones,

Priest at St. Theodosius in Tremont officiates wedding for the film *The Deer Hunter*.
Courtesy of Cleveland Memory Project, Michael Schwartz Library, Cleveland State University.

who renovated it to replicate its look in the film. The home was opened in
2006 as the *A Christmas Story* House and Museum.

It draws especially large crowds of visitors during the Christmas holiday
season. The *Christmas Story* 5K/10K Run takes place annually from

The *A Christmas Story* House. *Photo by Matthew Ginn (www.MatthewGinn.com).*

Tower City in downtown Cleveland, where Higbee's was converted into the Horseshoe Casino (where Michael Symon and Rocco Whalen have food outlets), to the Tremont house to benefit the *A Christmas Story* House Foundation. The foundation has provided grants to improve nearby housing in the area of Tremont in which it is located.

In addition to these major films, other filmmakers have used the Tremont neighborhood as a site for some of their shooting.

ANNUAL EVENTS

One of TWDC's major contributions to the growing recognition and popularity of the Tremont neighborhood has been its involvement in helping to stage annual events. These include festivals and celebratory events. TWDC's role has included managing some of these events and generating publicity for all on its website, in its newspaper and through other venues. Some of these events preceded its founding. Many of these events are profiled here.

GREEK FESTIVAL

Every Memorial Day weekend since 1970, the Tremont Greek Fest has welcomed visitors. Greek culture and cuisine are featured. The festival is centered on the Annunciation Greek Orthodox Church. It is the mother church to offshoot churches in Cleveland Heights and Rocky River. It was planned by members of the Pan Hellenic Society of Cleveland, founded in the early twentieth century. It has been at its current Tremont location (West Fourteenth and Fairfield) since 1918.

Polish Festival

Reflecting Tremont's large Polish population and the St. John Cantius Church and school (now a charter school), the Tremont Polish Festival is held there during the Labor Day weekend with food from Sokolowski's University Inn, polka bands and dancing.

Tremont Trek Home Tour

In 2002, the Tremont Trek Home Tour was created by some Tremont residents with assistance from Walter Wright of TWDC as a walking tour and progressive dinner at six Tremont homes. It was modeled on the Ohio City home tour and became a fundraiser for Tremont community programs through TWDC. While it began more as a neighborhood event, it grew considerably. The 2015 tour was attended by more than 250 participants traveling to the homes on Lolly the Trolley. Food and drinks from venues like Grumpy's Café, Prosperity Social Club, Tremont Taphouse, Tree House, Press Wine Bar and Civilization were served in the Grand Ball Room of Annunciation Greek Orthodox Church. Over Tremont Trek's fourteen years, about $100,000 has been raised for various Tremont organizations and their programs. In 2015, Tremont Trek donated about $13,000 to four Tremont projects: the Tremont Arts & Cultural Festival, Arts in August, improvements to the West Fourteenth Street Community Garden and the Cleveland Metroparks for an information kiosk to be placed at the Tremont trailhead of the Towpath (when it opens) near University Road. Tremont Trek was preceded by Tremont in Bloom, an annual architectural tour of Tremont buildings and some homes that was a fundraiser for TWDC.

Taste of Tremont

Begun in 2003, Taste of Tremont features Tremont businesses, especially its restaurants, bars and coffeehouses, with a beer and wine garden and live music. This July event now draws tens of thousands of visitors.

ARTS IN AUGUST

TWDC, city council member Joe Cimperman, LAND Studio and the Cleveland Public Theatre sponsor the annual Arts in August programs of professional dance, theater and music in Lincoln Park. The events are free. Selected Tremont restaurants support this event by donating 10 percent of one of their Tuesday sales. In August 2015, the participants were the Cleveland Shakespeare Festival, the Cleveland Public Theater, the Cleveland Jazz Orchestra, the Inlet Dance Theater, the Ground Works Dance Theater, Verb Ballets, Harmonia and the Cleveland Opera Theater.

ARTS & CULTURAL FESTIVAL

The Arts & Cultural Festival began in 1999. In 2015, sixty-seven juried artists participated, as well as fifty-four community, cultural and children's groups and seventeen performing arts groups.

ARTS RENAISSANCE TREMONT

The Pilgrim Congregational Church is home to Arts Renaissance Tremont. (See the YouTube video "Arts Renaissance Tremont—Cleveland's Best Kept Secret.") Admission is by freewill offering. This program celebrated its twenty-fourth season in 2014–15. Support was provided by Cuyahoga Arts and Culture, the George Gund Foundation, the Kulas Foundation and Tremont Trek. Participating performers for the 2014–15 season included Ars Futura, the Cleveland Orchestra Bass section, Burning River Brass, the Amici String Quartet, the Shaker Heights High School A Cappella Choirs and A Capella Ensembles and some individual performers.

2014 Tremont events. *Courtesy of Tremont West Development Corporation (TWDC).*

FARMERS' MARKET

In the summer, a farmers' market on Tuesdays draws dozens of vendors to Lincoln Park, with both resident and visitor customers frequenting it. It began in 2006 and, in 2015, opened in April and ran through October. It is one of several farmers' markets in Cleveland. It reflects the growing interest in the farm-to-table movement, encouraged by both community organizations and restaurateurs. Yoga is also offered during the market openings.

VALENTINE'S DAY CUPID'S UNDIE RUN

On February, 14, 2015, 850 runners participated in the third annual Cupid's Undie Run in Tremont in below-freezing weather. This is a national fundraiser for the Children's Tumor Foundation. It began in 2010 with participants in dozens of U.S. cities.

TREMONT HOLIDAY BREWHAHA

This is a pop-up shop and party event in December that began in 2011.

DYNGUS DAY

Dyngus Day is a Polish tradition celebrating the post-Lenten day after Easter. Cleveland's Detroit Shoreway neighborhood revived this event in 2012, and other neighborhoods have since joined it. The Tremont neighborhood, with its strong Polish heritage, also embraced this celebration beginning in 2014. Several restaurants and bars, plus the two Polish Legion posts, joined the celebration.

SMALL BUSINESSES

In its heyday as a bustling neighborhood of immigrants, Tremont was crowded with small shops, including a few grocery stores. Bar owner John Hotz remembered in 1998, "You had the markets, shoe stores, butcher shops, bakeries, beer joints, churches, just about anything you needed." In a February 22, 2003 Tremont Oral History interview, Emily Wish, the daughter of Polish immigrants, remembered living across the street from the St. John Cantius rectory:

> *What I liked when we were on that part of College* [Avenue], *no matter what way you turned, you turned to the corner, there's your grocery store, and right there's the florist, then a candy store, then the Lincoln bank, at that time it was called the Lincoln* [Heights] *bank. Then Fisher's* [grocery store], *across the street was the funeral director, Majewski. Then the nuns' house and the church and on the other side of Professor, we had the hardware store, the shoe store and across the street from there, you had a guy who sold appliances and the one that had the clothing store. And right on the corner again was another shoe store. Everything was just a little walk. It was good.*

Wish, like other residents interviewed, remembered street vendors like the waffle man, as well as the fortuneteller and the rag man who were traveling fixtures. Vic Hancuk described this well:

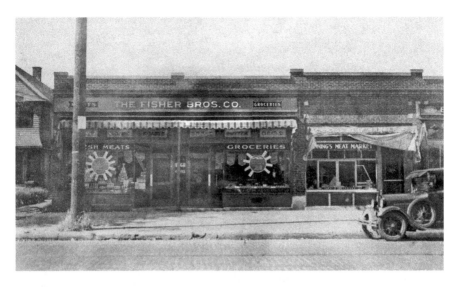

The Fisher Brothers Company grocery store. *Walter Leedy Postcard Collection, Cleveland Memory Project, Michael Schwartz Library, Cleveland State University.*

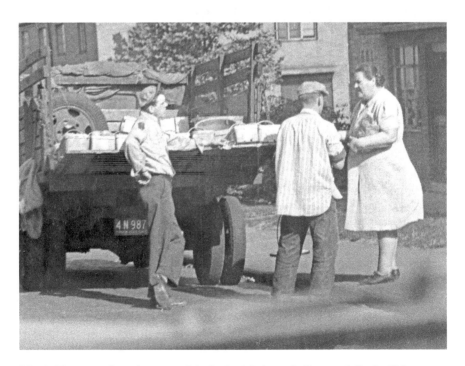

Men in Tremont sell products out of the back of their truck. *Courtesy of Cleveland Memory Project, Michael Schwartz Library, Cleveland State University.*

Another thing I remember there were horse drawn merchants all over the place. You had the pepareks they would get the old paper and rags. They would come down the streets, yelling "Papareks! Papareks!" They had the guys who were selling vegetables, and watermelons. There was one guy in particular, he would come down there and you could not miss him. He would say "Humppa Deda Deadeemelon! Humppa Deda Deadeemelon!" He was selling watermelons. There would be the guys who would sell fish—and one of the guys would sell fish right in my neighborhood—he would have this horn. He would blow the horn and you would go out and get your fish.

Ice and milk were also delivered to homes.

With its continuing decline in population, and before its revitalization over the past quarter century, Tremont lost most of these small businesses. Since then, in addition to businesses related to the arts and dining and drinks profiled earlier, Tremont has sustained some popular small businesses. A few of them are profiled here.

Mitch Paul has been in the bicycle business for thirty-six years as of 2015. Paul moved from suburban Shaker Heights to establish his Shaker Cycle shop at 2389 West Fifth Street. Paul feared that the opening of Steelyard Commons with its Walmart might drive him out of business. To the relief of Tremont's bicyclists, that did not occur.

Tremont Scoops, located at 2362 Professor and opened in 2001, is a Tremont favorite. Its original owner, Marianne Ludwig, and her husband moved to Tremont from the Bird Town neighborhood in suburban Lakewood. The building was previously occupied variously by a printing company, a florist shop, a shoe store and a barbershop. After she retired and left Tremont, it closed. In 2012, Tremont Scoops was reopened by a team of five new owners, much to the delight of its customers.

In February 2007, Dave Ferrante converted a one-hundred-year-old print shop at 1023 Kenilworth into Visible Voice Books, which was adjacent to buildings formerly occupied as crack houses that he bought and rented. His bookstore also offered music and poetry readings. (Ferrante talks about his bookstore in an October 13, 2009 YouTube video, "Visible Voice Books in Tremont.") In September 2014, Ferrante closed his independent bookstore, citing work and family pressures and a lack of enough foot traffic to sustain the business.

As these three examples show, owning and operating independent businesses in a small neighborhood, even with Tremont's attractions to visitors, can be

Tremont Scoops. *Photo by Matthew Ginn (www.MatthewGinn.com).*

a risky venture. This is especially true if there are competing national chain outlets nearby. However, some of these small businesses have managed to survive (although Tremont is now without an independent bookstore).

An interesting example of a Tremont small business expanding beyond the neighborhood is Banyan Tree. This eclectic boutique opened in 2001 and is located at 2242 College Avenue. In November 2014, its owner, Christie Murdoch, opened the Banyan Box as one of the first tenants of Small Box Cleveland, an experimental collection of shops in renovated shipping containers in downtown Cleveland's Warehouse District. In the fall of 2015, Murdoch announced that she would open a third store in the new Uptown district of University Circle on the city's East Side.

POLITICS

O ver its long history, the Tremont neighborhood has been represented by many politicians. It is currently represented by three different members of the seventeen-member Cleveland City Council: Joe Cimperman (Ward 3), Tony Brancatelli (Ward 12) and Brian Cummins (Ward 14). In 1993, Civilization coffeehouse owner Nancy Hocepl and attorney Jean Brandt both ran unsuccessfully for the Ward 13 (Tremont) city council seat held by incumbent Gary Paulenske. Three of its representatives on Cleveland's city council, both current and past, are profiled here.

DENNIS KUCINICH

Perhaps the best known and most controversial of all of Tremont's political representatives was Dennis Kucinich. Kucinich went on to become the "Boy Mayor" of Cleveland from 1977 to 1979 (surviving a recall but being defeated for reelection after a tumultuous single term), a longtime member of the U.S. Congress and a two-time presidential candidate. In his autobiography *The Courage to Survive*, Kucinich revealed his hard times growing up, including his time as a resident of the Tremont neighborhood.

Kucinich was one of six children growing up on the East Side of Cleveland. His father (of Croatian roots) was often unemployed, and the family moved many times, once living in their car after being evicted. After

his family moved to the West Side, Kucinich attended high school at St. John Cantius in Tremont, where he caddied to pay for his tuition. After graduating, Kucinich lived near the church while working as a copy boy at the *Plain Dealer* newspaper and then attending Cleveland State University.

In 1967, a not quite twenty-one-year-old Dennis Kucinich ran against the entrenched Cleveland City Council representative of Tremont's Ward 7 John T. Bilinski. In his autobiography, Kucinich described Bilinski:

> *At the doors of Ward Seven throughout the campaign I'd heard two opinions of Councilman Bilinski. One came from people who thought he had disgraced the Ward by his tax wrangling's and because he was disbarred from the practice of law. Others saw him as a sort of Ukrainian Robin Hood, who took from rich Uncle Sam and gave to the poor "pans and paniis." This group of people loved him because he went to their baptisms, weddings and family funerals. Some in the Ward spoke in awe of the Councilman getting their brother or father or selves out of jail by putting up the bond money out of his own pocket. He got people jobs. He did free legal work for some and helped others get drivers licenses. This portly man with a shock of white hair may have had trouble with his own income tax returns, he may have run his office out of his pockets, but when it came to politics, he never got anything mixed up. He knew his people and the people knew him.*

Against heavy odds, the youthful Kucinich lost by five hundred votes. In 1969, at the age of twenty-three, Kucinich won the seat. After two unsuccessful campaigns for Congress, he won election in 1975 as clerk of the municipal court prior to his election as mayor. His brother succeeded him as the city council member representing Tremont through 1979. Dennis Kucinich returned to Cleveland City Council briefly in 1983–85 before leaving Ohio for New Mexico. He returned in 1994 when he was

Dennis Kucinich. *Courtesy of U.S. Congress.*

elected to the Ohio state senate. In 1996, he did win that Congressional seat that had eluded him decades earlier and served until defeated in 2012. Congressman Kucinich ran unsuccessful long-shot presidential campaigns in 2004 and 2008.

Gus Frangos

An attorney, Frangos represented the Tremont neighborhood from 1986 to 1993. He defeated the incumbent Edmund Ciolek in the 1986 primary election and then won his first term. Frangos teamed up with Jim Rokakis, his fellow Greek (in heritage), in 2008–9 to create the Cuyahoga County land bank to address the foreclosure crisis that had resulted in thousands of abandoned homes in the county. Frangos became its president. Rokakis went on to create the Thriving Communities Institute, which has promoted land banking throughout much of the state of Ohio and has worked to obtain funding to demolish blighted abandoned housing in order to save neighborhoods threatened by blight.

Joe Cimperman

In 2015, Joe Cimperman was serving his seventh term on Cleveland's city council representing Ward 3. He was first elected in 1997, defeating numerous opponents. His family is Slovenian in heritage, and he grew up in the East Side Cleveland neighborhood of St. Clair Superior. They had Ukrainian and Greek friends in Tremont. Growing up, Cimperman played in the national Junior Tennis League competition and in a youth baseball league held at Tremont's Clark Field. After graduating from John Carroll University and serving in the Jesuit Volunteer Corps, Cimperman became an outreach worker at the Westside Catholic Center. He moved to Tremont in 1996, living above an art gallery, and became involved in Citizens to Save Metro Hospital and the Tremont Neighborhood Opportunity Center (an anti-poverty social service organization).

His ward has included Tremont and other Cleveland neighborhoods. Cimperman has been very supportive of TWDC and the Tremont block clubs. He has been a strong supporter of the arts, including Arts in

August in Lincoln Park and the Arts & Cultural Festival. He has championed programs to improve the Tremont neighborhood. In the transformation of the blighted Valleyview public housing project, he launched a "Welcome Back" signage campaign for the displaced tenants. On Cleveland's city council, he is best known for his support for urban agriculture, LGBT rights and wellness programs.

In 2008, Cimperman unsuccessfully challenged U.S. Congressman (and former Tremont City Council representative) Dennis Kucinich. In July of that year, Cimperman's Tremont home was destroyed by fire, later ruled arson. While there was an outpouring of community support, his family subsequently moved to the Ohio City neighborhood. In

Joe Cimperman of the Cleveland City Council. *Courtesy of Joe Cimperman.*

praising the residents and community organizations and institutions of Tremont (e.g., its churches, Merrick House and TWDC), Cimperman said that Tremont shows that you should never give up on any neighborhood. He cites the many community responses to crises (e.g., the threatened closing of the Tremont School on several occasions, the need for public access routes to Tremont and crimes like the shooting of the artist Jeff Chiplis) and efforts to improve the neighborhood. For him, the fighting spirit of its residents is a hallmark of the Tremont neighborhood.

LANDMARK BUILDINGS AND HISTORIC DISTRICTS

The Tremont neighborhood is one of Cleveland's most historic neighborhoods, with numerous historic buildings—most notably its many churches. There are also many other individual landmarked buildings, including the Union Gospel Press building, Lemko Hall and the Tremont School. An interesting building that has not been landmarked is the Ukrainian Labor Temple, located at the corner of West Eleventh Street and Auburn. It is now occupied by the CR Photography Studios. In a March 1, 2003 Tremont Oral History interview, Edith Hallal remembered the Temple, which once served as the Cleveland headquarters of the Ukrainian Communist Party. Her father had emigrated from Belarus, and she was married at the Temple: "It was like a social club. And I think there were a lot of shady things about it. I think it had a lot to do with socialism and communism. I remember my father was investigated for that."

The Tremont neighborhood is on the National Register of Historic Places. That part of Tremont bounded by the area immediately surrounding Lincoln Park contains the Tremont Historic District, one of Cleveland's many historic districts. It was established in 1987.

Led by TWDC staffer Andy Thomas and with the aid of historic preservation consultants Wendy Naylor and Diana Wellman, the Scranton Southside Historic District nomination was made in 2015 to the National Register of Historic Places, National Park Service and U.S. Department of the Interior. The area is that bordering Scranton Road, named for early Cleveland pioneer and merchant Joel Scranton. This road became a major

street in Tremont, traveled by electric streetcars until they were entirely replaced by the auto. The area was settled by the Germans. It contains two buildings on the National Register: St. Michael's Church and the Cleveland Dental Manufacturing building. There are five Cleveland landmarked buildings: Wagner Awning, the Cleveland Public Library Carnegie South Branch Library, the Emerson Casket Mansion and two churches. The district's nomination was approved in June 2015.

MAJOR DEVELOPMENT PROJECTS

Major development projects have taken place in Tremont during its revitalization. These projects have had an important impact on a neighborhood that suffered through a long period of stagnation and the loss of a considerable number of housing units and businesses. These projects have ranged from entirely new developments (e.g., Steelyard Commons) to adaptive reuse (e.g., Union Gospel Press/Tremont Place Lofts) to the conversion of Valleyview public housing into a mixed-tenure and mixed-income housing project.

Not all proposals have been supported by Tremont residents. For example, a proposal to build a "Greek Town" retail and entertainment project adjacent to the Annunciation Greek Orthodox Church ran into opposition in 1995. Posters reading, "Keep Tremont a Neighborhood, Not a Theme Park" appeared. Despite support from Cleveland City Council member Jim Rokakis and TWDC's executive director, Emily Lipovan, in the face of opposition, the investors pulled out and the proposal died. This reflects a division of opinion about the character of a revitalized Tremont. This was illustrated in an account of a summer of 1998 meeting of some longtime Tremont residents and business owners at the Grabowskis' Miracles' restaurant, according to the August 10–23, 1998 *Downtown Tab* article "Tremont in Transition." Attorney Jean Brandt was quoted as saying, "We can all agree…No strip malls, no McDonald's, no RiteAid, no Walgreens. Maintaining Tremont's small-town element is something that we all want." The writer explained:

The disagreements alluded to pertain to the occasional clashing between certain parties in the neighborhood, as Tremont develops through this stage of revitalization from a post-industrial blighted area to predominantly gentrified community…[S]uch dissent can be expected as part of the natural evolution of a city neighborhood. The area is a dynamic organism suffering through a period of growing or, more accurately, regenerating pains.

STEELYARD COMMONS

Once Cleveland was a leading factory town with mills dating from the late nineteenth century. With de-industrialization beginning in the late 1970s, many of these plants closed. In 2015, only the Arcelor Mittal steel mill still produced steel at a significant level. At the edge of southern Tremont in the valley, at the confluence of I-71 and the Jennings Freeway, there sits a regional shopping center named Steelyard Commons, which opened on October 23, 2007. Its anchor stores include a Walmart Supercenter, Home Depot and Target. Its developer operates similar centers in the eastern suburbs and in the western suburb of Avon. When it was first proposed, its labor union opponents argued against Walmart because of its non-union, low-wage workforce. It was also argued that it would hurt small businesses in nearby neighborhoods, including Tremont. However, the City of Cleveland supported the developer and helped to provide financing for his project, citing the need for this type of retail, the jobs that it would provide and the taxes that it would pay. Tremont residents have access to Steelyard Commons via West Fourteenth Street and via West Seventh Street and Quigley Road through the Flats.

UNION GOSPEL PRESS/TREMONT PLACE LOFTS

At the corner of West Seventh and Jefferson in Lower Tremont sits one of the most intriguing building complexes in Tremont. It is the sprawling landmark Union Gospel Press building. It once housed part of the failed Cleveland University campus and the two successor institutions that followed it. Its history is fascinating and was detailed in the August 12, 2001 *Plain Dealer Sunday Magazine* article "Echoes of the Past." In 1907, the Herald Publishing

House and the Gospel Workers Society moved from its headquarters in Williamsport, Pennsylvania, to this Tremont hillside site.

In 1895, Reverend William Brunner Musselman, a Mennonite preacher, and several women from his church had formed this home missionary ministry. They produced religious materials. In 1922, the group changed the name of the organization to the Union Gospel Press. Before they moved away in 1950, they added to the building complex. The building was mostly occupied by female workers/missionaries who lived in a dormitory on-site, as Emily Wish observed in a February 22, 2003 Tremont Oral History interview: "On weekends during the early years of the Society's presence in Cleveland many of the women donned the Gospel Worker Society navy blue-dress uniform to join sidewalk singing and preaching efforts conducted until 1923 on Public Square."

Emily Wish also remembered, "You'd get lost going in there, the tunnels in there. Wow. What was nice about them, they used to have these gospel singers, some of them living in there. They used to have some sort of church going on and every New Year's, it was snowing out in the middle of winter, they'd come to the corner of College where we lived, and they'd be singing gospels after midnight." The reclusive Musselman died in 1938 and was succeeded by his daughter, Mary.

The 300,000-square-foot complex of fifteen buildings, representing many additions to the original buildings, went through several owners following the departure of the Union Gospel Press. It was variously used for offices, light manufacturing and a rooming house. The complex fell into disrepair. In 1987, Joe Scully, a former ironworker, longshoreman, boxer and a metal sculptor, bought it for a nominal sum. In the *Plain Dealer Sunday Magazine* article "Echoes of the Past," published on August 12, 2001, Scully declared, "I'm like a hermit living in a cave, and they finally found me. I'm a big fan of destiny and fate. Destiny sent me here to save this building, and it's an honor to be here. I'm just a caretaker in time. I'm just passing through. This building will be here long after I'm gone. It's like the pyramids."

During his live/work residency, Scully was occasionally accompanied by would-be artists and squatters. "Scully rarely strays from the shadow of this historic legacy. He resides in an 1870 house adjoining the former factory complex, living what he describes as a modest lifestyle, utilizing lessons learned as one child in a family of ten," noted the August 12, 2001 *Plain Dealer Sunday Magazine*.

The eccentric Scully claimed to have rejected lucrative offers from private developers while hoping to see the complex become an artists'

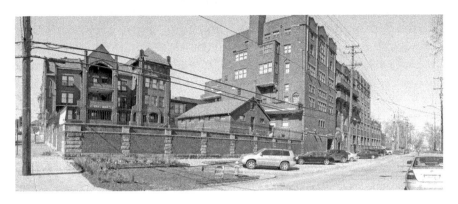

Union Gospel Press/Tremont Place Lofts. *Photo by Nat Neider.*

colony. TWDC made an agreement with him to develop the complex as affordable housing. However, this plan did not materialize. Instead, in 2003, Scully sold the buildings to a trio of Akron-based developers and then departed for Youngstown.

After arranging for a complicated combination of financing and undertaking a very difficult renovation plan, the renamed Tremont Place Lofts was transformed into a residential complex of 103 units. (Its renovation can be viewed in an August 10, 2009 YouTube video.) That same year, Will Hollingsworth moved to Tremont, where he became a bartender at Lolita. In 2014, he opened the sixty-seat bar at the base of the Tremont Place Lofts. He named it the Spotted Owl, described in the October 10, 2014 *Plain Dealer* article "Spotted Owl Is Wisely Infused with Spirits of Nuns and Poets." The bar was once the floor of a barn in central Ohio. For his cocktail bar, Hollingsworth went to Manhattan to apprentice at the Dead Rabbit cocktail bar. It could be said that this one odd building complex and its unusual history encompasses and epitomizes many of the changes in Tremont.

HOUSING

New housing projects have changed parts of the face of Tremont. The major higher-priced newly constructed projects have included Tremont Ridge, Bergen Village and Starkweather Place. Smaller residential projects have been built by Civic Builders. Tremont Pointe replaced the Valleyview low-income public housing project with the mixed-income and mixed-tenure HOPE VI project. TWDC sponsored the Phoenix Project to provide

new modestly priced owner-occupied housing. The redevelopment of the Union Gospel Press building into apartments represents the most ambitious adaptive reuse project. Other older distinctive buildings like Lemko Hall and the Lincoln Park Baths have also been converted to housing. New residential development has been proposed for Duck Island.

THE FAIRMONT CREAMERY

In 1930, celebrating its fortieth birthday, the Fairmont Creamery Company of Omaha, Nebraska, opened its Cleveland Fairmont Creamery in a 100,000-square-foot brick building in Tremont on a sloping hillside on West Seventeenth Street. In 2013, with the creamery long closed and the building mostly vacant, it was purchased by Sustainable Community Associates (SCA). Formed in 2002, SCA is a trio of Oberlin College graduates who received considerable acclaim for their first development project, which was featured in the *New York Times* and on National Public Radio (NPR).

Fairmont Creamery. *Photo by Nat Neider.*

With complicated financing and historic tax credits, SCA planned a mixed-use adaptive reuse of the landmarked building. Its plan was undeterred by a January 2014 fire that started shortly after the renovation began. The renovated building opened in late 2014 with the debut of the 14,000-square-foot Tremont Athletic Club. Adjacent is the Good to Go fresh foods shop featuring organic, GMO-free, humanely raised selections (many local). This is a far cry from the days of the immigrants and their hardscrabble existence and food traditional to their European cultures. However, those same immigrants once used the recreational facilities such as those in the Pilgrim Church and Tremont School. The rest of the building is devoted to residential units and offices.

While doing this project, SCA purchased the Ohio Awning & Manufacturing building at the corner of Scranton Road and Auburn Avenue. The ninety-thousand-square-foot landmarked facility was built in 1895. The current business (then named Wagner Awning) moved into it in 1931. It has produced canvas products, including military tents and awnings, since it began in the post–Civil War era. It is moving to another Cleveland location. SCA plans to convert the building into a mixed-use residential and commercial building by 2016. TWDC, through its Development Director, played a role in linking SCA with the building's owner.

TOWPATH TRAIL

For the last few decades, dedicated advocates have worked to complete the Towpath Trail from mid-Ohio to the shore of Lake Erie in downtown Cleveland. When completed, this trail will be 110 miles in length. As of 2015, 85 miles have been completed, much of it on the path of the nineteenth-century Ohio canal (now the Ohio & Erie Canalway, a National Heritage Area). South of Cleveland, the Towpath Trail runs through the Cuyahoga Valley National Park. The trail has now reached Cleveland at the Steelyard Commons shopping center. The next planned stretch is Stage 3 of the Extension Project that will complete the trail within the city of Cleveland and Cuyahoga County. It will run from the northern entrance of Steelyard Commons to Literary Road along the eastern edge of Tremont and the edges of Clark Field. Stage 4 will bridge Literary and then head north along University Road past Sokolowskis' University Inn before descending into the Scranton Flats. It is scheduled for completion in 2018. This will be a major recreational addition for both resident and visitor bicyclists and hikers. In addition, a Lake Link Trail will go to Lake Erie. The initial phase that runs from Hoople's (bar/restaurant) and the Columbus Road Bridge to Scranton Road in Tremont was dedicated in August 2015.

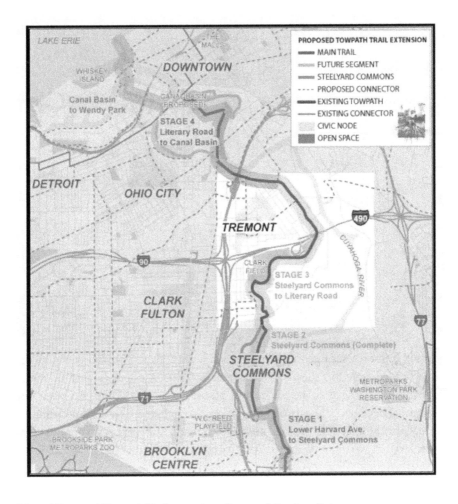

Map of Proposed Towpath Trail extension. *Courtesy of Canalway Partners.*

CHALLENGES

POPULATION: CONTINUING DECLINE AND CHANGING DEMOGRAPHICS

Despite Tremont's resurgence over the past few decades, its population continued to decline, as noted in the 2010 U.S. Census. From a population of 8,138 in 2000 it fell to 6,912 in 2010, a decline of 15 percent. This decline paralleled the continuing decline of the city of Cleveland's population. However, according to estimates in the latest American Community Survey (ACS), Tremont's population increased by 1,126 (17 percent) in 2012, compared to 2010. Hispanics increased by 29.5 percent, African Americans by 25 percent and whites by 12.4 percent. Whites still make up a majority of Tremont's population, at 70 percent of its residents (although some of these would be Hispanic in ethnicity).

The mix of Tremont's population has changed over time, including changes effected by the arrival of three groups: migrants from Appalachia, Hispanics (mostly Puerto Rican) and, most recently, more affluent buyers of the new higher-priced housing built in Tremont. The African American population in the past was mostly concentrated in the Valleyview public housing project, now converted to the mixed-income Tremont Pointe project. While these different groups have mostly lived in an atmosphere of tolerance, this was broken on July 31, 2007, when the home of African American Rogina Weakley at West Twelfth Street and Mentor was burned down. One month earlier, the garage of Vanessa Glover Freeman was also set on fire. Both were believed to be racial hate crimes. In response, several hundred people

gathered at Lincoln Park on August 30 for a show of unity under the slogan "Tremont Unite." Cleveland mayor Frank Jackson, Tremont City Council member Joe Cimperman and Cleveland NAACP president Stanley Miller were among those attending the event to condemn racial bigotry.

In 2010, Tremont's white (non-Hispanic) population was 3,721 (53.4 percent), the black (non-Hispanic) population was 1,485 (23.2 percent) and the Hispanic population was 1,455 (23.2 percent). Of the 1,895 Hispanics living in Tremont in 2000, 863 (45.5 percent) were born in Puerto Rico. While the proportion of blacks and Hispanics remained the same in 2010 as in 2000, the proportion of whites in Tremont increased from 46.6 percent to 53.4 percent, even though the actual number of whites dropped by more than 600. In the 2012 ACS estimates, whites continued to be the racial majority, with about one-third of the residents comprising minority races and Hispanics (by ethnicity) comprising 22 percent of the population. This contrasts with the city of Cleveland's population profile in which whites are a minority and a majority of the city's total population are minorities, primarily blacks and Hispanics. TWDC continues to promote diversity as a hallmark of Tremont. The neighborhood remains diverse in race/ethnicity, as these data indicate, and also in income—there is a very high poverty rate but also a growing number of higher-income households.

HOUSING

According to the U.S. Census, in 2000 there were 3,949 housing units in Tremont. Balancing the loss of units from the demolition of the Valleyview public housing project has been the addition of new housing units from the new residential developments, plus housing units added through adaptive reuse. In 2010, there were 3,983 housing units, a net gain of 34 units from 2000. The vacancy numbers were virtually unchanged over this decade: 647 in 2000 and 657 in 2010. The majority of housing in Tremont remains rental (65 percent of the units according to the 2012 ACS estimate). As to affordability, in the 2000 U.S. Census, the median monthly gross rent in Tremont was $435 compared to $465 in the city of Cleveland. According to City-Data, in 2013 the median monthly rent in Tremont was $563, higher than the $506 cost in Cleveland. Of the 1,134 owner-occupied housing units in the 2012 ACS estimate, the median value was $73,962, which was almost

9 percent less than the citywide median value of $80,900. Almost one-third (434) had a value of $100,000 or more, and 12 had values of $500,000 to $749,999. This reflects the growth of higher-priced owner-occupied housing in Tremont beginning with the Tremont Ridge project.

HOSPITALS

Independent community hospitals like Grace Hospital in Tremont have increasingly been bought by larger hospital systems or closed. This trend reflects the financial problems that these hospitals have faced. Grace, founded in 1910, experienced those problems in the 1980s. An effort to hire a spine surgeon to attract a new type of patient and expand failed in 1987 in the face of neighborhood protests. However, Grace did become a specialty hospital registered as a long-term acute care hospital. It remains based at 2307 West Fourteenth Street.

Not far away on West Twenty-fifth Street is MetroHealth (formerly known as Metro General), Cuyahoga County's public hospital. Founded in 1837 as the City Hospital of Cleveland, it was transferred to Cuyahoga County in 1958. MetroHealth serves the poor, including those living in the Tremont neighborhood. It, too, has experienced financial problems and was threatened with closure or privatization, but community organizations and activists like Gail Long of Merrick House, as well as U.S. Congressman Dennis Kucinich, rallied to its support. In 1971, the Tremont Free People's Clinic was opened. It was replaced in 1985 by a city health clinic. While MetroHealth has opened branch clinics throughout the county, it is now in the process of a planned transformation of its main campus, according to the October 18, 2015 *Plain Dealer*. TWDC received a grant from Cleveland Neighborhood Progress to engage residents in the creation of a community-based plan around the MetroHealth campus.

BRIDGE CLOSINGS

Due to its topography, Tremont has always been relatively isolated. This was aggravated by the construction of the freeways (I-71 and I-490) that cut through parts of the neighborhood. It has relied on bridges to provide access

to the rest of Cleveland for its residents and visitors. Periodic bridge closings have made life difficult for Tremont's residents and businesses. In 1978, the Clark Avenue Bridge was closed, and in 1984, it was demolished. In 1982, the Abbey Avenue Bridge was closed. This made it difficult for Tremont residents to go to the West Side Market. As Vic Hancuk noted:

> *One of the big things was to go to the West Side Market. The Market was not actually part of the South Side, but we considered it part of the South Side, because so many people went there from the South Side. Basically, you got there by bus, taking the Fairfield bus or the Fourteenth Street bus, and going across Abbey Avenue and getting off there. Sometimes money was a little short [and] we would walk across the bridge.*

Then the northbound ramp to I-90 was closed. The Tremont neighborhood and its leaders fought successfully to restore the I-90 ramp. TWDC formed the Free Tremont Committee to lobby the City of Cleveland for replacement access infrastructure. In 1983, it held a race to downtown, won by Jeff Chiplis, to dramatize the problems caused by the bridge closings.

Jeff Chiplis, Free Tremont Road Rally. *Courtesy of Cleveland Memory Project, Michael Schwartz Library, Cleveland State University.*

Alternative travel routes through the Flats were not considered very viable given the confusing maze of roads, often in poor condition, and the industry-related traffic. A "Tremont Funbook" was written with a survival map outlining routes to neighborhood businesses. It also contained several songs. One was "Tremont Is Our Home" (sung to the tune of "The Battle Hymn of the Republic"):

My eyes can see our neighborhood that rises over the flats,
We've had our share of problems: arson, burglary, and rats,
Yet we're fighting to make it better like a pack of polecats,
For Tremont is our home.
They divided up our neighborhood by building interstates,
Then they blocked up all our access out, and urged us to vacate.
But we won't leave! Our future's here!! We'll never abdicate;
For Tremont is our home.
Our fire station was taken from us and other services, too.
When we yelled, we were ignored; we're not very well-to-do.
But when we raise our voices as one, they listen to me and you
For Tremont is our home.

Chorus

But to get here is an endeavor
Tremont, yours and mine forever
Still, it's a neighborhood with pride,
For Tremont is our home.

Eventually, Tremont access routes were restored and improved, including the Abbey Avenue Bridge. In 2015, a new Columbus Avenue Bridge opened, while work on the Innerbelt project continued with the rebuilding of the I-90 second bridge connecting Tremont to downtown Cleveland.

Air Pollution

In the heyday of manufacturing, the largely immigrant workers who labored in the plants in the industrial valley below Tremont and their families had to live with pollution from those plants that covered their homes and the

Tremont neighborhood. In a March 8, 2003 Tremont Oral History interview, Father Joseph Hilinski of Our Lady of Mercy Church recalled the factory pollution, including the smell: "There was a grit, literally a grit, on the house you noticed a grit. Everything had a grittiness to it. The fence always had a film from this soot that was around."

He remembered his grandmother on Thurman Avenue dusting furniture daily to remove the dust from the steel mills. In an April 4, 2003 Tremont Oral History interview, Vic Hancuk, whose parents emigrated from Galicia in the Carpathian Mountains, also recalled, "One of the things that I remember vividly was the red skies at night from the steel mills down in the flats not too far away, not saying all of this was nice, remember all the dirt from the mills and the other factories. Sometimes we would get reddish dirt, sometimes we would get silver spectings from some of the factories."

In more recent times, some Tremont residents sought to fight that industrial pollution. A February 17–23, 1999 *Cleveland Free Times* article described the effect of pollution from the LTV steel plant on neighborhoods adjacent to the industrial valley. Tremont resident Jose Santiago (later a city council member representing the adjoining Ward 14 Clark Fulton neighborhood from 2005 to 2009) complained, "My complaint is not only do our homes get covered with this stuff [fine black grit] and we have to spend money every year blasting the houses with power washers, but it eats away at outside furniture and covers cars. If we plant vegetable gardens, then we're eating that stuff, and kids with their toys and bikes put their fingers in their mouths."

Longtime Tremont resident Martha Buck, who migrated to Tremont from West Virginia in 1964 and who was quoted about the daily effect of the pollution, had five relatives who worked in the steel mills in the valley, illustrating the tradeoff between jobs and the quality of life. Whether from Appalachia or Puerto Rico (as in Santiago's father's case), the migrants came for the jobs in the factories, just like their European counterparts earlier. In December 1998, the U.S. EPA sued LTV's Cleveland Works for violating the federal Clean Air Act.

During that period, residents from the Holmden-Buhrer-Rowley block club, where Santiago lived, sought compensation from J&L Steel for damage to the exteriors of their homes from the company's operations in the Flats, although their Summer Paint Program employing students to paint the homes of elderly and disabled homeowners was funded by the city with a federal grant. J&L responded to their complaints by denying that its operations had caused the problem.

In 1986, the Osterland Company, founded by Tremont resident G.R. Osterland, began to produce asphalt in the Flats. This produced fumes that affected Tremont residents considered noxious. They also were displeased by noise from Osterland's operations. Beginning in 1992, some Tremont residents and business owners (including the Sokolowskis and Bob Hocepl of Civilization) formed the North Tremont Coalition and launched a campaign against pollution from Osterland's asphalt plant in the Flats. The coalition complained to Cleveland's Division of Air Pollution Control and the Ohio Environmental Protection Agency.

In July 1992, Cleveland's Division of Environment issued an odor abatement order against Osterland. After Osterland spent hundreds of thousands of dollars to respond but the problems continued, Osterland then moved its stack but without a permit. The coalition then complained about this to the city. The following year, Osterland sought to obtain approval for a second plant, which the coalition opposed. After a May 2, 1993 coalition demonstration, its protests triggered media coverage. The city then denied a permit for the second plant, and Osterland appealed to Cleveland's Building Standards Appeals Board.

Osterland also sued the coalition and seven Tremont individuals (including Bernie Sokolowski and Bob Hocepl) active in the campaign. Its lawsuit claimed that their actions constituted libel and slander and asked for $750,000 in damages. This is known as a Strategic Lawsuit Against Public Participation (SLAPP). The defense against these claims is that the citizen actions seeking governmental action are protected by the First Amendment's Free Speech clause under the United States Constitution. Unlike some other states, Ohio has no regulation of SLAPP suits. The American Civil Liberties Union (ACLU) intervened on behalf of the "North Tremont Seven." The parties settled the case in May 1994, with Osterland paying the coalition's legal defense costs.

In 2005, Ohio Citizen Action (OCA) launched a campaign to have the Arcelor Mittal steel plant in the Flats below Tremont (the former LTV plant and Cleveland's last remaining major operating steel plant) reduce its pollution. Arcelor Mittal is the world's largest steel maker. In an August 22–28, 2007 *SCENE Magazine* article, "Battling the Steel Baron," an OCA-led Tremont "wipe down" protest is described:

On a bright Saturday morning in Tremont's Lincoln Park, Liz Ilg [an OCA organizer] shouts directions to troops over music from a community production of Shakespeare. Volunteers are given clipboards,

spray bottles filled with organic cleanser, and white rags silk-screened with Citizen Action's ever-familiar war-cry "Mittal Steel: Clean Up for Real." They head down to the street to scrub black soot from houses. The group, led by German immigrant Ina Roth, wanders down Fruit Avenue, where dilapidated shacks intermingle with condos straight out of The Jetsons, and pit bulls bark through fences at coiffed shih tzus. The street used to be home to families of steelworkers, hard-knuckled Russkies and Poles...Just across the freeway is the mill, blowing ghastly plumes in the air.

In 2007, OCA filed a complaint with the U.S. Environmental Protection Agency (EPA) that the Arcelor Mittal plant had inadequate air quality controls. With the closing of many of the heavy manufacturing plants in the industrial valley, air pollution became less of an issue for residents of the adjacent neighborhoods like Tremont.

On November 14, 2013, President Barack Obama chose Arcelor Mittal's Cleveland plant as the site for his address on the U.S. manufacturing economy. He was introduced by Tom Scott, a third-generation steel worker. The president praised the company, its Indian CEO Lakshmi Mittal and its Cleveland plant. For the history of the Arcelor Mittal steel plant, visit its website.

CRIME

The 1936 sociological study of Tremont gave the impression of a poor, crime-ridden slum neighborhood. Joe Filkowski was the best known of the Tremont-based gangsters of this period. In the 1970s, Tremont was the site of widespread arson. Lincoln Park was an open-air drug market and not normally used by most residents after dark. The same was true of Clark Field. Before Tremont's revitalization, many suburbanites viewed Cleveland neighborhoods like it as dangerous places. For example, Grumpy's owner, Kathy Owad, had that impression when she first came to Tremont. Occasional well-publicized incidents like the arson fire at city council member Joe Cimperman's home in 2008 and the 2010 shooting of artist Jeff Chiplis by robbers give visitors a negative impression. Break-ins and carjackings also continue to contribute to a negative view of Tremont. A May 28–June 4, 2008 *SCENE Magazine* article described Tremont as "Grand Theft Auto": "In Tremont, it's rare to find a resident who doesn't have a firsthand experience with auto theft. Many have become unwilling experts

on the finer points of car crime…After all, Tremont is a Shangri-la—an island of easily flipped foreign cars, lax policing, and the renewable naivete, which comes with the constant parade of visiting suburbanites."

Writing in the August 2015 issue of *The Tremonster* (a monthly neighborhood newspaper begun in 2010), Yvonne Bruce recounted reporting a nighttime car burglar to the Cleveland police:

> *Car riflers are the bane of Tremont, especially on the less-traveled residential streets like ours. We never leave anything of value in our cars, but occasionally forget to lock the doors. Whenever we do, the next morning the doors are ajar and every cup holder and compartment is open. Neighbors who should know better have had GPS devices, laptops, clothes, and tools stolen from their cars. Sometimes the cars themselves (or the wheels) are gone when the whistling Tremont resident heads outside at seven a.m.*

However, while residents are certainly concerned about crime like other city dwellers, this has not deterred many newcomers and visitors from settling in or visiting Tremont. TWDC has a Safety Committee that monitors neighborhood concerns about crime and meets with representatives of the Cleveland Police Department. The Tremont block clubs are a constant community voice about crime and resident reactions to crime. There is also a Tremont Crime Watch on Facebook, which was initiated in 2015 by art gallery owner Paul Duda in response to several carjackings.

Clark Field

South of Tremont in the industrial valley (West Seventh Street off West Eleventh and Clark) sits Clark Field, a city park. Once it was a busy playground for Tremont residents. Then it fell into decline, with the city failing to maintain the park and its recreational programs. It became an eyesore and a dangerous place to visit, often the site of stripped and abandoned stolen cars. In 2002, the Friends of Clark Field was formed. The Mentor-Castle-Clark block club pushed its formation. Longtime resident Bev Wurm became its head. The Friends organized volunteers to begin a cleanup of the park. In 2003, Kent State University's Cleveland Urban Design Collaborative worked with the city's Department of Parks, Recreation and Properties to develop a master plan for the restoration of

the park. Since then, considerable investment made Clark Field once again a popular facility. In 2015, the City of Cleveland is expected to begin to make major improvements to Clark Field's facilities.

On June 24, 2005, there was a new addition to Clark Field: Cleveland's first dog park. It was promoted by Tremont Residents Empowering Animals to Socialize (TREATS). The city of Cleveland's dog kennels are located next to Clark Field. Animal-friendly Tremont has two animal veterinary clinics: the Gateway Animal Clinic and the Tremont Animal Clinic. In addition, the Cleveland Animal Protective League, founded in 1913, is located in Tremont. In 2004, Tremont resident Becca Riker founded the Mutt Hutt, a pet sitting and dog walking service located at 2603 Scranton Road. She also operates Second Hand Mutts, a dog adoption service. In 2012, Cleveland Dog Walk was founded in Tremont. In contrast to all of these dog- and pet-friendly activities, back in the 1970s wild dog packs once roamed the streets of Tremont, as observed by David Sharkey of the PURE realty firm, then a Tremont resident.

PARKING

Tremont was not developed for the automobile. Its streets (many still paved with bricks) can be narrow, and some of the small lots do not have enough room for garages. In the days of the walking neighborhood, and with the depopulation of Tremont, parking was not of great concern to the residents. However, that has changed in the most recent period with the advent of numerous events and bars and restaurants attracting large numbers of visitors. As a result, residents and some businesses can be understandably annoyed when they cannot park or find that unauthorized parking has occurred beyond designated spaces. With the intervention of TWDC, some of the restaurants have valet parking. Resident-only permit parking has not yet been adopted. Construction of a compact parking garage was discussed in the 2007 SII plan. However, given the estimated costs, the building of a city-owned and operated garage to relieve parking pressures appears to be unlikely. Compared to Tremont's decline, this is probably the kind of problem that a neighborhood like Tremont, growing in popularity and visitors, has to adjust to despite some inconvenience to residents.

FUTURE PLANS AND PROSPECTS
FOR A CHANGING TREMONT

The year 2018 will mark the 200th anniversary of the arrival of the first pioneer American settlers in what is now the Tremont neighborhood. Over almost two centuries, this Cleveland neighborhood has undergone many changes, including five different names. Its major changes have mirrored those of Cleveland.

It evolved from a farming community to an urban village populated largely by poor European immigrants in an era of industrialization, to a neighborhood in decline with de-industrialization and de-population and then to a revitalized destination neighborhood featuring the arts and cuisine. Tremont now attracts tens of thousands of visitors annually to events held monthly, seasonally and annually. Its population has changed over time: first the New Englanders, then the various European immigrant groups and, more recently, migrants from Puerto Rico and Appalachia and more affluent homeowners. Its most notable institutional feature has been its many churches.

However, while St. Wendelin survived a closing by the Catholic Diocese, some of these churches have seen a decline of their congregations to the point that they have been converted to other uses (e.g., Holy Ghost and Our Lady of Mercy). Tremont's revival has seen the restoration of Lincoln Park as a central gathering place and Clark Field as a recreational center and the adaptive reuse of some of its historic buildings (e.g., Lemko Hall, the Lincoln Park Baths, the Union Gospel Press and the Fairmont Creamery). The fates of the Tremont Montessori School building remains uncertain, while the

CPL South Branch Library will be renovated. Also to be determined is the impact of the future redevelopment of MetroHealth Hospital's main campus. These institutions are key assets, and their impact will influence the future of Tremont.

Tremont has also suffered major tragedies. These include the Central Viaduct accidental deaths and the displacement of so many residents by the two highways that cut through parts of the neighborhood. Its residents have had to endure the pollution from the factories in the industrial valley that employed so many of its residents for decades. Immigrants, the residents of the Valleyview public housing project and even today nearly one-third of its residents have experienced poverty.

Yet Tremont's residents have rallied to protect and improve the neighborhood. From acting to free Lincoln (then Pelton) Park from private control to organizing to address its isolation when bridges were closed or eliminated; fighting arson and other crime; resisting industrial pollution; and fighting to save their elementary school, a public library and Metro hospital, their ability to organize has been a hallmark throughout much of Tremont's history. Organizations like the block clubs and TWDC and institutions like the churches and Merrick House have been critical in these many struggles. This makes for an arresting history with fascinating characters, several of whom have been profiled. The Tremont neighborhood has been first in Cleveland in having the first (although short-lived) university, the first public art gallery and the first dog park.

What is the future likely to hold for the Tremont neighborhood? Given its more recent popularity, it is likely to see more new housing built (e.g., in Duck Island) and adaptive reuse of more of its historic buildings. However, more new housing is not likely to significantly increase its current population given the limited availability of buildable land and the pattern of low-rise buildings. The disparity between those who are living below the poverty line and affluent newcomers will probably continue to engender some tension.

There are strong community forces supportive of current residents who might be threatened with displacement. But as with many of the artists who spearheaded the revitalization of Tremont in the 1980s and 1990s, rising real estate values and prices could lead to displacement of those of lesser income, whether residents or businesses. In addition to the many festivals, bars and restaurants, the completion of the Towpath Trail through the neighborhood will undoubtedly attract even more visitors. Drawing even more visitors will keep parking issues on the neighborhood's agenda.

Given its relative isolation from the rest of the city, Tremont has the feel of an urban village. (See the TWDC's October 17, 2014 YouTube video "Tremont, Cleveland's Urban Village" for more information.) Despite Tremont's attractions for visitors for its many events, churches, bars and restaurants, on quieter days its residents can enjoy its amenities in a walkable environment. Walking tours of the Lincoln Park area and the churches of Tremont can be accessed through Cleveland Historical. Residents can savor its views, play at Clark Field, worship at its churches and shop at the nearby West Side Market and Steelyard Commons. They can interact with their neighbors through the block clubs and community organizations like the Tremont Gardeners, churches, the summer weekly farmers' market and the Tremont Montessori School if they have children enrolled there. While not without problems that any urban neighborhood faces, Tremont's future seems promising. Its residents remain resilient in addressing the problems that it faces, as they have in the past.

BIBLIOGRAPHY

Bellamy, John Stark, II. *They Died Crawling and Other Tales of Cleveland Woe: True Stories of the Foulest Crimes and Worst Disasters in Cleveland History*. Cleveland, OH: Gray and Company, 1995.

Boyer, James, and Maria Boyer. *A History of St. Augustine Church*. Cleveland, OH: St. Augustine Parish, 2010.

Campbell, Thomas F., and Edward M. Miggins, eds. *The Birth of Modern Cleveland, 1865–1930*. London: Associated University Presses, 1988.

DeCapite, Raymond. *The Coming of Fabrizze*. N.p.: Black Squirrel Books, 1960.

Ellis, Lloyd. *A Guide to Greater Cleveland's Sacred Landmarks*. Kent, OH: Kent State University Press, 2012.

Grabowski, John J., Judith Zielinski-Zak, Alice Broberg and Ralph Wroblewski. *Polish Americans and Their Communities of Cleveland*. Cleveland, OH: Cleveland Ethnic Heritage Studies, Cleveland State University, 1976.

Harper, Nile. *Urban Churches, Vital Signs: Beyond Charity Toward Justice*. Grand Rapids, MI: William B. Eerdmans Publishing Company, 1999.

Hendry, Charles E., and Margaret T. Svendsen. *Between Spires and Stacks*. Cleveland: Welfare Federation, 1936.

Kucinich, Dennis J. *The Courage to Survive*. Beverly Hills, CA: Phoenix Books, 2007.

Megles, Susi, Martina Tybor and Mark Stolarik. *Slovak Americans and Their Communities in Cleveland*. Cleveland, OH: Cleveland Ethnic Heritage Studies, Cleveland State University, 1978.

Miller, Carol Poh, and Robert Wheeler. *Cleveland: A Concise History, 1796–1990*. Bloomington: Indiana University Press, 1990.

Oldenburg, Ray, ed. *Celebrating the Third Place: Inspiring Stories about the "Great Good Places" at the Heart of Our Communities*. New York: Marlowe & Company, 2001.

Ruhlman, Michael. *The Soul of a Chef: The Journey toward Perfection*. New York: Penguin Books, 2001.

White, Terry L. *With Doors Wide Open: A History of Pilgrim Congregational United Church of Christ, 1959–2009 Commemorating the 150ᵗʰ Anniversary*. Cleveland, OH: Pilgrim Church, 2009.

INTERNET RESOURCES

Angelica Pozo. http://angelicapozo.com.

Annunciation Greek Orthodox Church. annunciationcleveland.net.

Arcelor Mittal. "Steel Strong 100." http://usa.arcelormittal.com/Steel-Strong-100.

Arts Renaissance Tremont. ArtConcerts.org.

Banyan Tree. www.shopbanyantree.com.

The Bourbon Street Barrel Room. bourbonstreetbarrelroom.com.

Byzantine Catholic Cultural Center. www.byzcathculturalcenter.org.

Carpatho-Rusyns. http://www.carpatho-rusyn.org/history.htm.

A Christmas Story House and Museum. www.AChristmasStoryHouse.com.

Civic Builders. civicbuilders.com.

Civilization. cafecivilization.com.

Cleveland Animal Protective League. clevelandapl.org.

Cleveland Dog Walk. http://www.cledogwalk.com.

Cleveland Historical. http://clevelandhistorical.org.

Cleveland Historical Walking Tours. http://clevelandhistorical.org/tours.

Cleveland Memory Project (Tremont). Cleveland State University Schwartz Library, Cleveland, Ohio. http://ulib.csuohio.edu/cdm/search/searchtermTremont.

Cleveland's Cultural Gardens. www.culturalgardens.org.

Cleveland State University History Department. Cleveland Regional Oral History Project. Center for Public History and Digital Humanities. digitalhumanities@csuohio.edu.

———. Tremont Oral History Project. http://academic.csuohio.edu/tah/tremont.

Cool Cleveland. coolcleveland.com.

Edison's Pub. edisonspub.com.

Fahrenheit. chefroccowhalen.com/Fahrenheit-cleveland.

Fairmont Creamery Facebook page. https://www.facebook.com/thefairmontcreamery.

GardenWalk Cleveland. "Tremont." http://www.gardenwalkcleveland.org/neighborhood/tremont.

Grumpy's. grumpys-café.com.

The Hotz Café. hotzcafe.com.

Lamson and Sessions. "Our History." http://lamson-sessions.com/OurHistory.html.

Lolita. lolitarestaurent.com.

Merrick House. merrickhouse.org.

Mutt Hutt. http://themutthutt.com/about/meet-the-owner.

Ohio & Erie Canalway, a National Heritage Area. ohioanderiecanalway.com.

Parallax. parallaxtremont.com.

Pat's in the Flats. patsintheflats.com.

Pilgrim Congregational Church. pilgrimalive.org.

Plain Dealer. Cleveland.com.

Professor Avenue Streetscape Project. http://new.gardenwalkcleveland.org/garden/2342-professor-ave.

Progressive Urban Real Estate (PURE). progressiveurban.com.

Prosperity Social Club. prosperitysocialclub.com.

The Rowley Inn. therowleyinn.com.

SCENE Magazine. clevescene.com.

Sokolowski's University Inn. sokolowskis.com.

St. Augustine Roman Catholic Church. staugustine-west14.org.

St. John Cantius Church. cantius.org.

St. Theodosius Russian Orthodox Cathedral. sttheodosius.org.

St. Wendelin Church. stwendelin.org.

Sustainable Community Associates (SCA). http://sustainableca.com.

Teaching Cleveland Digital. "Tremont." NE Ohio Neighborhoods and Their History. http://teachingcleveland.org.

Tom Roese. http://thomasroese.com.

Tree House. treehousecleveland.com.

Tremont Crime Watch Facebook page. https://www.facebook.com/tremontcrimewatch.

Tremont Gardeners. http://tremontgardeners.org.

Tremont Greek Festival. tremontgreekfest.com.

Tremont Pointe. tremontpointe.com.

Tremont Scoops. tremontscoops.com.

Tremont Trek Home Tour. tremonttrek.org.

Tremont West—Arts & Cultural Festival. tremontwest.org/index/Tremont-arts-cultural-festival.

Tremont West—Arts in August. tremontwest.org/index/arts-in-august.

Tremont West Development Corporation (TWDC). tremontwest.org.

Tremont West—Farmers' Market. tremontwest.org/index/tremont-farmers-market.

Ukrainian Museum-Archives. umacleveland.org.

Zion United Church of Christ. zionucctremont.org.

INDEX

ABOUT THE AUTHOR

W. Dennis Keating is an Emeritus Professor of urban planning and law at Cleveland State University. He is co-author of *Revitalizing Urban Neighborhoods*, *Rebuilding Urban Neighborhoods* and other publications on cities, urban policy and housing.